REYNOLDS STONE

REYNOLDS STONE
ENGRAVINGS

WITH AN INTRODUCTION
BY THE ARTIST

AND AN APPRECIATION
BY KENNETH CLARK

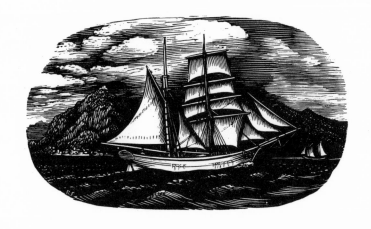

JOHN MURRAY

50 ALBEMARLE STREET LONDON

0 7195 3434 8 (trade)
0 7195 3435 6 (limited)

British edition published by
John Murray (Publishers) Ltd
50 Albemarle Street, London WIX 4BD

United States edition published by
The Stephen Greene Press
Fessenden Road at Indian Flat
Brattleboro, Vermont 05301

Printed in England at
The Curwen Press
Plaistow, London E I 3

CONTENTS

FOR JANET

INTRODUCTION

REYNOLDS STONE

My father, like my grandfather, was a schoolmaster. Both were classical scholars. My grandfather, E. D. Stone (1832–1916), was a poet and a master of classical prosody; he used monotonously to win the classical competitions in the *Westminster Gazette*. (One week the competition was 'Name three events of European importance.' The winning entry included 'E.D.S. not getting the *Westminster Gazette* prize'.) He was the only one of my grandparents who was alive after my birth, and I remember him vividly with awe and affection. His deafness in old age was no barrier. After many years of Eton, perhaps tired of the increasing tyranny of athletics and formalism, he light-heartedly started his own private school near Broadstairs on the North Foreland. It was a success and survived until recently. Percy Lubbock has left a charming account of the school and its headmaster in his *Shades of Eton*. My father, E. W. Stone (1867–1936), one of ten children, followed in his footsteps at Eton and was also a classical scholar with a successful 'house' whose old boys met in his memory for nearly fifty years: a tribute to their affection for him. All his life he was doing good by stealth.

My mother (1872–1925) came from a different background. She was christened Laura Neville and her father J. E. Bovill was a corn merchant who lived in Dorking in a house called Sondes Place. His large family (she was the sixteenth) all tended to ride to hounds and there were enough brothers to make up a cricket eleven. Though she was expert on a horse she had other talents which she did not neglect. She studied drawing under Tonks and in 1904–5 was in Japan during the war with Russia, and painted there; some of her drawings were used by the *Graphic*.

I have a mental image of my parents riding together in Windsor Park in the years before 1914 and of my mother in the garden of their house at Eton, Baldwin's Bec, wearing one of the enormous wide-brimmed hats of the period. She made the strip of land opposite the house and across the road a paradise of roses. A gouache drawing of it dated 1914 by a friend, Alexander Mavrogodarto, brings it vividly to mind. She was a disciple of Gertrude Jekyll and I still have a few 'Munstead' flower-glasses and her copies of Miss Jekyll's books with their admirable binding designs by the author. My mother once invited the Provost to tea to meet Madame Abel Chatenay, General MacArthur, Hugh Dixon, etc., and he came in a frock coat! At least that is the story I remember her telling.

[ix]

I was born in 1909 and christened Reynolds after Sir Joshua (the relationship was through one of his sisters). I cannot be certain of remembering anything specific until the outbreak of the First World War, except going in a wagonette and watching the beautiful rounded hindquarters of our mare, Ada. My father was over-age and it was impossible for a five-year-old to take in its enormity, but something of its horror did eventually percolate. The two much-loved horses were at once sacrificed. Later I can remember a nursery maid in tears when yet another of her brothers was killed. My two sisters and I loved the sergeant husband of our nurse with his waxed moustache and mock French. The disgrace of the Kaiser seemed complete when his banner and helm were removed from St George's Chapel at Windsor. We were sometimes invited to the organ loft by Sir Walter Parratt and would wait for this delightful old man and great musician to come up before the service and vault over the organ seat. Up there one was on a level with the heraldic splendour of the banners and helms. When the armistice was signed the headmaster circulated a statement for all school house notice-boards which ran: 'Owing to the cessation of hostilities there will be a half-holiday . . .' This understatement of all time was counterbalanced for me by watching boys who had dragged a bath half-way out of an upper window and were madly beating it.

I was slow at learning to read and saw no point in books unless they had pictures, but I was lucky to be brought up on most of the usual admirable Victorian children's books: Richard Doyle's *Fairies*, marvellously engraved and printed in colour by Edmund Evans; George MacDonald's *At the Back of the North Wind*, illustrated by Arthur Hughes; *Alice in Wonderland* and *Through the Looking Glass*; Edward Lear; Caldecote – *The Three Jolly Huntsmen* and Aesop's *Fables* modernised; Walter Crane; Beatrix Potter; the American *Hollow Tree and Deep Woods* (1901) by Albert Bigelow Paine; Harvey Darton's *The Seven Champions of Christendom* (1913); Théodore Cahu's *Richelieu*, illustrated by Maurice Leloir. All of these gave enormous pleasure and continue to do so, not least to my children.

I was a fairly observant little boy – I liked hunting for insects and examining them closely and was keenly interested in the shapes of birds and horses. My mother gave me a book called *The Horse and the War*, and I admired the skill of its illustrations. I would look for pictures of horses and ponies in encyclopedias so as to choose one to pretend to be. (The heavy tread of a Clydesdale was not easy to imitate!) Our night nursery looked on the graveyard and the chapel where there was an owl and pigeons who perched high up on the vertiginous sloping steps of the buttresses. I longed to join them. I watched, holding my breath, a kingfisher diving for minnows in the backwater of the Thames opposite our house. When I must have been very young I once leant out of a pram to stroke the breast of a

[x]

wild duck hanging over the edge of a poulterer's marble slab in the high street, and it fell to the ground. 'You will have the police after you for that,' I was told by the pram pusher, and for a week or two afterwards I lived in terror of being arrested. I was painfully shy and disliked the formal walks with my sisters in the playing fields where the pram-pushing nannies congregated to gossip and where their older charges were expected to play together. Only rain spared us, and I have loved rain ever since, because it made it possible to get on with one's toys and making things with meccano. The enterprising makers divided their product into sets so that one slowly graduated to a more advanced box. One could then build quite complicated things like model cranes. I was mad about cranes for a long time and considered myself a connoisseur of real ones. The final achievement was constructing a machine which could turn out a great variety of 'engine-turned' patterns. I was also very interested in the springs of cars and carriages and railway engines and rolling stock. There was a fleet of small freelance motor buses nicknamed 'scarlet runners' that plied between Windsor and Slough and were clearly home-made or rather adapted from saloon models like T-Fords. Their sagging rear springs were closely observed by me. In 1916 the perambulators were temporarily checked. A great gale blew down 400 trees in Windsor Park and laid low twelve enormous elms in the playing fields. I remember the look of devastation and the shock of a piece of our little world being turned upside-down, and how the great trunks were fun to play on. The floods were another excitement when our garden was under water, although they were never on the scale of earlier ones, we were told.

My mother was a friend of John Guille Millais, the son of the P.R.A., and probably it was through him that my parents once called on his friend Archibald Thorburn and took me with them. There and then Thorburn gave me a coloured sketch of a stonechat which I have treasured ever since.

In 1919 I was sent to Durnford, a boarding school in the small grey stone Purbeck village of Langton Matravers. The headmaster, Thomas Pellatt, looked alarming and piratical, but he and his wife were exceedingly kind and very good indeed at managing large numbers of little boys. Once the misery of leaving home was conquered after a week or two, I enjoyed a great deal of it. The long sleep of childhood was beginning to come to an end. To the north of the school were woods and a noble line of downland and to the south over several fields and stone walls was the sea. We were allowed a great deal of freedom and on Sunday afternoons I would wander off by myself towards Corfe Castle and try and draw the landscape with watercolour. I was once given a piece of cake by Mrs Pellatt as a reward for one of these efforts.

I was smuggled, so to speak, into Eton because, although my Latin was up

to scratch, I had learned no mathematics at Durnford. The Common Entrance exam revealed that I had three marks, one for arithmetic, one for algebra, and one for geometry, and those were consolation marks. I was twelve and was put into the lowest form presided over by a much-loved master who had no objection to gentle chaos. I had to take 'extras' in mathematics and almost at once the black cloud that subject meant to me was blown away thanks to the brilliant teaching of F. G. Channon whose love for it was perhaps unconsciously aesthetic. My father had not yet retired and to begin with I was boarded in his house. This made my life difficult and I had to cultivate the art of escaping notice. The Greek word for it I still remember.

The art master was Eric Powell, a heroic figure who had been an aviator in the First World War. The school had a sensible arrangement which allowed one to produce drawings in the holidays and so avoid reading the set book. I enjoyed this holiday task and would sometimes go out drawing with my mother. Perhaps the most gifted pupil, who had been at Durnford with me, and who seemed almost to take over the art school, was Robin Darwin. His drive and intelligence were worthy of his clan.

Thanks to the school, it was possible to pursue a subject that had no connection with the curriculum. For some inexplicable reason I spent my spare moments hunting through books that had drawings or photographs or engravings of sailing vessels. They had to be traders not yachts. The 19th century was the time when they reached their peak in development and were at their most beautiful. I turned over every page of the long run of the *Illustrated London News* in the school library and would spend time before school in the afternoon calling on old Mr Luxmoore to look at and read *Last Days of Mast and Sail* by Sir Alan Moore with drawings by R. Morton Nance, which had been given to him by the author. It was given to me after Luxmoore's death.

My father retired in 1923 and lived in a house near Bridport that had been built by my great-grandmother in 1870. Her father had lived in Dorchester and there were many connections with the county. From then on I felt Dorset was home. In the autumn of 1925 my mother died suddenly. My two sisters were younger than me and this disaster was perhaps worse for them even than for me, and much worse for my father. I was sixteen.

When I was seventeen, my tutor, Jan Grace, the kindest of men, gently suggested that I was wasting my time and should go to Cambridge. How simple it was in those days! Magdalene College accepted me and I read History. I had always tried to draw and in the summer vacation of 1929 I stayed in Rye and worked hard at it with the idea of testing myself. I had an introduction to call on Colonel Buchanan and his beautiful wife who lived in the near-by village of Iden. He was a farmer and an artist and his

medieval house, with its original king-post still in position, was unaffect-edly romantic. In the main living room was a superb Samuel Palmer of a cowshed with a gloriously rotting roof (now in the Pierpont Morgan Library) and in a bookshelf by the great fireplace *The Memoir of Edward Calvert* by his son containing his miraculous early engravings. I was bowled over. Paul Nash was living in Iden at that time and I remember seeing him painting *Northern Adventure* and a series of wind-breaks and ladders.

In 1930 I took my degree and my immediate future was settled in an unlikely way. Francis Scott, a young don at Magdalene, had recently been the assistant printer at the Cambridge University Press. He suggested that Walter Lewis, the University Printer, might allow me to study printing as an unofficial apprentice. W.L. agreed.

I started with setting up type with the compositors and the real appren-tices with the father of the chapel keeping an eye on us. They did not seem to mind me, and I soon felt like one of them. I was intrigued by all the words used by printers, some of them corruptions of old French, and later the Press still went on a wayzgoose every year, an outing dating at least as early as the 17th century.

I did not imagine that I should ever become a printer but by good fortune I learnt to see the craft as an art. After a spell of hand-setting I was taken in hand by the overseer of the composing rooms: F. G. Nobbs was a formidable and gifted man who took the trouble to teach me all he knew. He worshipped Stanley Morison, then and for long afterwards the typo-graphical adviser to the Cambridge University Press and a great friend of Walter Lewis. Thus I knew a great deal about Morison before I met him.

The seven volumes of *The Fleuron: A Journal of Typography*, edited first by Oliver Simon and then Morison, were lying about in Nobbs's cubicle. I devoured them all, from the first article 'Printers' Flowers and Arabesques' by Francis Meynell and Stanley Morison in 1923. I was excited by these designs and found in the library of the Fitzwilliam Museum a copy of one of the finest of the arabesque pattern books, *La Fleur de la Science de Pour-traicture* by Pellegrino (Paris 1530). I traced one of them. In the last number I greatly admired the engravings of Eric Gill and his mastery of the alphabet.

I started to try and engrave. It may have been partly the result of spend-ing some time in the foundry of the Press where electrotypes and stereo-types were made and where 'fudging up sorts' was done, that is, adapting a type's size or shape with an engraving tool. Certainly my first engraving was done on a piece of type metal. Later Walter Lewis gave me some boxwood blocks from the now unique firm of Lawrence & Son in London. I had also discovered Thomas Bewick in the famous bookshop of David who made a point of buying Bewicks whenever he could and sold them for generously

low prices. I have a perfect copy of the *Quadrupeds* which cost one shilling because the binding was in pieces. I also greatly admired the engravings of Gwen Raverat.

I was at the Press until 1932 but clearly could not stay there indefinitely. I got a job with a small printer in Taunton, Barnicott & Pearce, but before going I was allowed, thanks to Walter Lewis, to stay for a short time with Eric Gill.

I had been at the V. and A. where I had just bought four large sheets reproducing his lettering. On the way back to Cambridge by train I found myself sitting opposite to him. I had seen him recently giving a lecture at Cambridge. Shy as I was I had the nerve to unroll my purchases from the V. and A. He was immediately friendly and talked all the way to Cambridge, much of it about Stanley Morison who was perhaps his greatest friend. He was going to Cambridge to incise a crocodile on the outside of the small laboratory where Lord Rutherford was to make his nuclear experiments. It has weathered well.

I spent a fortnight at Gill's house, Pigotts. The first person I saw was David Jones. In the great barn the carving of *Prospero and Ariel* for the BBC was nearly finished. It looked splendid in the half-darkness of the barn. David had made a drawing of a girl on the back of it. René Hague was printing on a splendid early Albion iron press. I was allowed to attempt to engrave an alphabet and draw letters. In the evenings the daughters and sons-in-law would gather round the patriarchal hearth. Afterwards I walked down the hill through a dark wood to a cottage where I was put up. The atmosphere of work and worship was very powerful and impressive and made the outside world seem banal and vulgar, but I knew that I would have had to escape if anyone had asked me to stay. It was a very stimulating fortnight.

Barnicott & Pearce was an old firm that was competing with another printing house down the street. Typography as practised by the Cambridge University Press was unknown to it. The front in Fore Street was a shop, selling books, stationery and oddments. I liked the back part, particularly the composing room where two delightful old compositors worked with ancient wooden cases. In the machine room there were a number of early wood blocks inherited from a previous firm. Mr Barnicott was kind enough to give them to me.

On my afternoon off I would often push-bike over the Quantock hills to Bridgwater and to Combwich, a village on the Parrett with a backwater where the last of the Severn trows, a local type of ketch-rigged sailing vessel, would lie. I once got up at 4 a.m. in the summer, bicycled to Combwich in time to photograph a trow leaving under sail and was back in the printing office by 8 a.m. There was also a bookseller in Combwich in a

large barn at the end of the village. There I discovered the illustrated wood-engraved books of the 1850s and 1860s. I was very interested in their engraving technique as I had been with Bewick and his followers in the 1830s and up to the 1840s. Today, alas, there are now no trows and no bookshop and the old harbour warehouses have been destroyed.

I used to engrave at night in the attic of the little red brick house in Mansfield Road where I was a lodger. I became very fond of my landlady Mrs Cutts, and her husband, who was a carpenter. Now the whole row will soon be demolished.

I found that I was getting an increasing number of small engraving jobs thanks to Beatrice Warde and Sir Francis Meynell and Stanley Morison. I remember the excitement of an important looking envelope from America! It was from the calligrapher Paul Standard asking for two writing paper headings.

To the great relief of my boss I sacked myself. He wanted a young man who would take over the business. I became a free-lance and have been one ever since. In 1939 I taught myself to cut letters in stone and continued to draw out of doors, sometimes with engravings in mind.

AN APPRECIATION

KENNETH CLARK

Reynolds Stone's account of his childhood, straightforward and transparent as it seems, reveals much more about the nature of his art than is apparent at a first reading. There is his vision of heraldry from the organ loft of St George's Chapel, his love of cranes, foreshadowing his love of ancient printing presses, his passion for wood engravings of sailing ships, showing his need for precise and intricate detail; and at the end comes his apprenticeship as a typesetter, and his visit to Eric Gill. Nevertheless I fancy that the admirers of Reynolds Stone's work will still have some questions to ask. I certainly had. I asked them and, although Reynolds Stone is reluctant to talk about himself and his art, I received a few answers which I shall try to convey to the reader.

To begin with, not everybody knows the difference between a woodcut and a wood engraving. A woodcut is done with the grain of the wood. The parts that are to remain white are cut away, the parts that are to appear as black lines or areas stand up in relief. This is effectively the technique of the printing press, and thus became the natural medium of the first illustrated printed books. By (or on behalf of) Dürer and Holbein it was brought to a point of skill and refinement that has never been equalled, except by the executants of Japanese prints in the 18th century. Gradually the craft of the woodcut declined. The only recent artist of real distinction to use it was the great Norwegian, Edvard Munch, who did coloured woodcuts in which the blocks are as beautiful as the impressions. Reynolds Stone (and it would be hard to imagine an artist more different from Munch) has never done a woodcut. He is a *wood engraver*.

In this process the lines are incised across the end grain of a piece of boxwood (now increasingly hard to get), exactly as in a metal engraving, and the main tool is called a graver, which you use with a forward movement, while twisting and turning the block on a small pad, so the actual block is a sort of negative.

Wood engraving was used occasionally for commercial purposes in the 17th century. But unquestionably the first man to use it in the creation of works of art was the Newcastle wood engraver of the late 18th century, Thomas Bewick. I have used the word 'art': in fact Bewick's most famous collections, the *Birds* and the *Quadrupeds*, had a scientific intention. Bewick took immense pains to make his representations of birds as accurate as

possible. But the same love of perfection was focused in the decorative effect of the engravings, and in his backgrounds Bewick revealed a feeling for nature that can properly be called Wordsworthian, for Wordsworth himself wrote of him 'Oh would that the genius of Bewick were mine.' Both in their poetic feeling and in their perfect adaption of medium to subject, Bewick's engravings exist in their own right as works of art.

The memory of Bewick dominates one side of Reynolds Stone's art. But he also has an immense admiration for the wood engravings done by anonymous craftsmen to reproduce the charming drawings and watercolours done by English illustrators of the mid 19th century. 'I could never achieve their skill,' he says, but studying them, in an unequalled collection of their books, has relieved him from the too restricting influence of Bewick. He particularly admires the work of the brothers Dalziel and their assistants, who reproduced the drawings and watercolours of the Pre-Raphaelites, rendering colour in black and white with extraordinary effect. The Dalziels claimed only to be craftsmen, and added no creative element to the visual arts. Nevertheless, a well-engraved and printed wood block has a special quality which must have pleased the artists (except of course Rossetti!). Most of them also liked drawing on wood. William Morris was right to have all the illustrations and decorations engraved on wood for his Kelmscott Press.

Bewick has been a dominating influence on Reynolds Stone; but before coming to that part of his work I must consider some of his other achievements. The first, and in a sense the best known, is lettering. His Introduction tells how he was apprenticed to a printer and learnt the craft at an early age. He was deeply influenced by the great master of typography, Stanley Morison, then championing a revival of pure classic lettering. His finest engravings of inscriptions, bookplates or nameplates, are masterpieces of this style. They are refinements upon the Renaissance versions of antique inscriptions. The men of the Renaissance, with their passion for geometry, had determined to found their letters on precise measurements, and had produced very elaborate geometrical schemes to justify every proportion. Only the tail of the 'Q' escaped from their rigour. Reynolds Stone tells me that when he was still at the Cambridge University Press he bought a copy of a facsimile of the first Renaissance writing book by Ludovico Vicentino. It has an introduction by Morison and was printed by Giovanni Mardersteig. This was a key book. Stone was also encouraged by James Wardrop of the Victoria and Albert Museum, who gave him work and was always glad to show him his unrivalled collection of photographs of Renaissance calligraphy.

Quite early in his career as a letterer, Reynolds Stone was enchanted by the more elaborate style, also invented in the 16th century, in which the

late Renaissance italic grows beautiful fronds and curlicues, known as 'flourishes', to fill the space around the inscription. Most of his bookplates were printed white on a black (or dark red) ground, and there is no doubt that these flourishes give the inscriptions a life and variety which they would otherwise have lacked. They have been imitated, but no one else has done them with Reynolds Stone's sure taste, and sense of the appropriate.

The flourishes of Renaissance calligraphers, which were the source of his style, had been reproduced by metal engraving. To execute them with a chisel on wood must surely be extremely difficult, especially as all the words must be engraved in reverse. I asked Reynolds Stone if he drew them on the block before cutting them. He said that he sometimes did so roughly, but that often his chisel 'ran away with him', or 'did the work for him'. No doubt it is this element of spontaneity that gives his flourishes their vitality and grace.

Consciously or unconsciously the average man knows Reynolds Stone's lettering better than any other part of his work. It meets and satisfies the eye in dozens of bookplates or labels, and we find ourselves looking with pleasure at these anonymous pieces of lettering before we realise that in fact only one man could have done them. One example of his design is known to everyone: the ten- and five-pound notes issued in 1963, and now superseded by much less skilful designs. They were probably the best designed notes in the world, but the peculiar conditions that had to be met have had a slightly inhibiting effect, and they show the extent to which Reynolds Stone's art is linked to the medium of wood engraving.

Perhaps the earliest pieces to show him using this medium with a full sense of its decorative possibilities are in his heraldic or emblematic designs. He himself denies any specialist knowledge of heraldry. He loves its combination of decorative archaism and rich allusion, but he is not concerned with the controversial niceties of that exasperating science. But to a man who lives through his eyes, the abstractions of heraldry are limiting. Even Reynolds Stone's earlier emblematic designs are artfully welded to the observation of nature. Stylised forms grow more real, and by 1935, in *A Butler's Recipe Book*, the head- and tail-pieces consist of closely observed pieces of still life. Two years later, in the chapter headings of Rousseau's *Confessions*, the union of the decorative and the closely observed shows even greater mastery. This is the mature Reynolds Stone, such as he was to remain, with one important development.

This development was due to his love of nature. He has continued to perfect his alphabets, execute scrupulous inscriptions and dozens of bookplates, and never, in a single instance, has he lowered his standards. But his heart is engaged by the woods, weeds, streams, mosses and wild flowers that he sees around him. His view of nature is limited and optimistic. He has

none of that feeling of menace, which made Bewick include in his tiny engravings men hanging from boughs and other disturbing reminders of the human condition. The horse dying in the rain, or the animals starving in the snow, are not for Reynolds Stone. But this limitation has given his work a consistent poetry and a richness of texture which have not been achieved by Bewick's other descendants.

Reynolds Stone had always done some painting, but in the last ten years he has blossomed into a watercolour painter of great distinction. His work has grown progressively freer and more personal, and something of this can be felt in his later wood engravings.

Although he may flinch from this kind of exposure I cannot describe the qualities of Reynolds Stone's finest work without saying something about his character and his surroundings. He must forgive me if I treat him as I would an artist of an earlier century. He is completely a country man, and his rare visits to London are undertaken with reluctance and gloom. He hates all change, and sees the modern world as constantly threatening everything he loves, in particular the countryside. As a matter of fact the part of Dorset in which he lives is singularly unchanged, and from the hill behind his house one can look for twenty miles in every direction without seeing a single unsightly development. His house is half-way down the hill, is surrounded by trees, so that it is absolutely invisible until one comes upon it. It is an 18th-century rectory, built in the days when the Church offered a more rewarding career. Many civilised Englishmen live in old rectories, but this one is exceptional for several reasons. It has not been shampooed, and looks exactly as it must have done in the early 19th century; and as one stands at the front door one becomes aware of a sound unusual in England, the sound of running water, of streams and miniature waterfalls, which come from a deep valley or dell that lies to the west of the house. This dell is a wilderness in the sense that all the flowers are wild flowers, nothing is ever cut and no weed is uprooted. They grow under large and splendid trees, which Reynolds Stone loves more than anything in the world except his family. Down the steep slope of the dell twisty paths lead to a multi-plicity of rivulets, some of which run in and out of a lake. The foreground focus is very close, the background dense and mysterious. This has become more and more the world of Reynolds Stone's engravings, and it is only after wandering round the dell and stopping at every miniature cascade, that one begins to realise how much of his visual imagination has been nourished by the relationship of detail and mystery that is everywhere in his own surroundings.

Back at the house, where everything shows the signs of love and long usage, there is another surprise: Reynolds Stone's matchless collection of old hand-presses. Side by side with his love of nature there has always been

an interest in paleotechnics, and over the years he has bought, for unbelievably small sums, eleven early hand-presses, in which a simple, utilitarian process is combined with a grandiose sculptural design. Happy days when such a combination was still thought desirable! They are not all in working order, but two of them, including the oldest, are in continued use for the printing of his engravings. To see him stroking his presses is to recognise the balance between the poetic lover of nature and the craftsman-perfectionist which is the basis of Reynolds Stone's art.

Thirty years ago the word escapist was still a term of abuse. Now that we have so much more to escape from we may view the concept more tolerantly. But even if it is still reprehensible for the average man to shut his eyes to the conditions of his time, no one with any knowledge of artists will deny that they can be escapists without detriment to their art. In order to realise a compulsive dream a certain degree of withdrawal is necessary. Perfection is best achieved in solitude. The perfection achieved in Reynolds Stone's lettering, decorative emblems and microcosms of nature is dependent on a stillness and concentration which daily contact with the world would not have allowed. The volume of his work is large, the works themselves very small, and at first we may feel in them a certain element of repetition. But if we look as carefully and attentively as he does, we can see how each one records, with loving precision, an individual experience.

A NOTE ON WOOD ENGRAVING

REYNOLDS STONE

The words 'woodcut' and 'wood engraving' are used indiscriminately for two different techniques for engraving or cutting designs that can be printed. The method that can truly be called engraving is comparatively recent and its origin obscure. The medium is the boxwood block engraved on the end of the grain with tools similar to those used on metal. This involves a forward movement of the hand, the reverse of the knife action which had produced the woodcut so popular in the 16th century, cut across the grain with great skill by professionals some of whose names are known. However at least as early as the 17th century small unimportant blocks had been engraved on the end of the grain. The Clarendon Press at Oxford has preserved several. One indeed was found in 1892 under the floorboards of the Sheldonian Theatre where Dr Fell set up his press. It had been printed in 1695, a simple diagram in a book on mathematics.

The fine work of the copperplate engravers continued to dominate the reproduction of illustrations throughout the 18th century. The only wood-cutter who made any impact was a Frenchman called Papillion, who stuck to the traditional plank method and whose *Traité de la Gravure en Bois* of 1766 made it clear that in his view this was the only proper procedure on wood.

In 1767 Thomas Bewick's father apprenticed him to a general metal engraver in Newcastle who, as a sideline, provided local printers with small wood engravings. The boy's natural talent for drawing made him useful in this side of the business. Without realising its implications he began to transform a craft whose potential had escaped notice for at least 100 years. In his lifetime this once despised technique caught the attention of many people, including George III. Immediately after the Napoleonic Wars an English engraver introduced the method to France, and an American who had seen Bewick's *Quadrupeds* copied them and became the first American wood engraver. Without Thomas Bewick it seems unlikely that either Blake or Calvert would have taken to wood engraving. Late in life in 1821 Blake was asked to contribute illustrations for a schoolbook, Thornton's Virgil. They are small miracles and were worshipped by his circle of young friends, particularly Palmer and Calvert. That Calvert gave up engraving when still young is a tragedy.

Later and for most of the 19th century it became the most convenient and

the cheapest way of reproducing all kinds of drawings and photographs. It had the great advantage that it did not need to be printed separately from letterpress, and, as Bewick had shown, was capable of great clarity on a small scale. Soon it was possible to increase sizes to fill large periodicals such as the *Illustrated London News*. Engravers such as the Dalziels and Edmund Evans were enormously skilful and made possible the flowering of book illustration in the fifties and sixties. The artists they worked for liked drawing on wood. A long review of the engraver W. J. Linton's monumental *The Masters of Wood Engraving* in the *Athenaeum* of 18 July 1891 ends with this sentence: 'To the final question, "Can the art of engraving in wood renew its life?" the answer is scarcely hopeful.'

However, the art was not dead. Already, in the 1890s there were artists who liked engraving their own work, notably Lucien Pissarro, encouraged by Rickets and Shannon. In the 1920s and 1930s there was a further revival with artists including Robert Gibbings, Eric Gill, David Jones, Gwen Raverat and Eric Ravilious.

NOTES

c *L'Européen.* Device of an international literary magazine, now defunct. Commissioned by Stanley Morison. 1936.

D Editions des Bibliothèques Nationales. Device. Commissioned by Stanley Morison. 1930s.

E Tauchnitz Centenary, 1837–1937. Commissioned by John Holroyd-Reece for Bernhard Tauchnitz Verlag's centenary catalogue. 1937. *See also* 8 F.

F The Albatross Mystery Club. Device. Commissioned for a Tauchnitz library of mystery titles published in English. 1930s.

G F. N. Schiller. Bookplate. Commissioned for the collector of Chinese ceramics and Old Master paintings. *c.* 1935.

Page 9

A With Barnicott and Pearce's Compliments. Cut for Mr Barnicott during RS's working for his press. Early 1930s.

B Isobel Rose Walker. Book label. Early 1930s.

c Ariel Mercer. Book label. Early 1930s.

D Nancy Tennant. Book label. Late 1930s.

E Suzanne de Saint-Mathurin. Book label. 1934.

F Mas St. Gabriel. Letterheading. Commissioned by John Holroyd-Reece for his house near Grasse. 1930s.

G Dorothy Teacher. Book label. Date unknown.

Page 10

A Device for A L'Ecu de France, Jermyn Street, London. Commissioned through Oliver Simon when the restaurant first opened and in use ever since. 1938.

B 3 Albert Terrace. Letterheading. Commissioned by (Sir) George Barnes, first Director of the BBC Third Programme. An answer to a perennial problem as taxi-drivers seldom knew where in London to bring his guests. 1934–5. *See also* 38 F and 101 G.

c RDV. Book label. Date unknown.

D Jocelyn Proby. Bookplate. Given by his brother, Granville Proby. Early 1930s.

E–G

Three coats of arms. From *A History of St. Louis* by John, Lord of Joinville, Seneschal of Champagne. Gregynog Press, 1937. RS engraved coats for all the main

characters in the chronicle which were then hand-coloured.

Page 11

A Bracken Cottage, Bucklebury. Letterheading. The Stones' first home. 1938.

B JS. Bookplate. Cut by RS for his wife, Janet. 1938.

c Brian North Lee. Bookplate. 1972.

D Francis Holland School Library. Bookplate. Designed for the school at Clarence Gate, London, the library of which has since been altered. Commissioned through a relative of Lowes Dalbiac Luard, painter of horses. *c.* 1937.

E John Miceli. Bookplate. *c.* 1936.

Page 12

A The Royal Arms for the Order of Service on the occasion of the Coronation of H.M. King George VI. Commissioned by Cambridge University Press. 1937.

B Title-page device for *The Royal Record of Tree Planting* in honour of the Coronation of H.M. King George VI. Commissioned by Stanley Morison. Unpublished. The Coronation Planting Committee declined it as they wished to encourage the planting of the sessile oak rather than the common oak depicted but had not informed RS of their decision. 1939.

c Arms of Squire Law Library, Cambridge. Bookplate. The arms of the Regius Professor of Civil Law at Cambridge were first adopted in the 16th century. Commissioned by the University Printer at Cambridge. 1938.

Page 13

A Landscape suggested by travels in Greece. Unpublished. 1939.

B Illustration for Aesop's *Fables*. A copy of one of Richard Austin's illustrations. Commissioned by Stanley Morison and recut by RS as an example of Austin's work for *Richard Austin: Engraver to the Printing Trade between the years 1788 and 1830*, printed by Walter Lewis for friends of the Cambridge University Press, New Year's Day, 1937. The engraving was cut partly in the British Museum. 1936.

c Landscape suggested by travels in Greece. Used as Christmas card, 1946. Unpublished. 1936.

D Christmas card for RS's aunt, Lady (Compton) Mackenzie. *c.* 1939.

E Cover design for the Eton College Carol Service sheet. Commissioned by H. C. Babington-Smith. 1936.

Page 14

A Jacket and title-page design for *Ding Dong Bell* by Walter de la Mare. Commissioned by Richard de la Mare. Faber & Faber, 1936.

B Title-page illustration for the 1st edn. of *The Open Air: An Anthology of English Country Life* by Adrian Bell. Faber & Faber, 1936. *See also* 14 D and 22–24.

C Title-page design for *Ambush of Young Days* by Alison Uttley. Faber & Faber, 1937.

D Jacket design for the 1st edn. of *The Open Air* by Adrian Bell. Faber & Faber, 1936.

E Jacket spine design for *Ambush of Young Days* by Alison Uttley. Faber & Faber, 1937.

F–G Illustrations for *The Annihilation of Man* by Leslie Paul. Faber & Faber, 1944.

Pages 15 to 17

Title-page and illustrations for *The Praise and Happinesse of the Countrie-Life* (1651 edn.) by Don Antonio de Guevara, translated from the Spanish by H. Vaughan. Gregynog Press, 1938. The Gregynog Press was owned by the Misses Davies and run at that time by James Wardrop, who commissioned these illustrations.

Pages 18 and 19

Illustrations for *Old English Wines and Cordials* by T. Read, compiled by J. E. Masters. High House Press, 1938. Mr and Mrs James Masters had an Albion press above their shop in Shaftesbury, Dorset, and published a number of hand-printed books.

Page 20

A Design for *Diggings from many Ampersandhogs*. Typophiles Society, New York, 1936. The book was produced as a *jeu d'esprit* by the Society with each member contributing a design. *See also* 20 B.

B Device for the Typophiles Society, New York. 1937.

C James Wardrop. Letterheading. Commissioned by the scholar and calligrapher when he worked at the Victoria and Albert Museum Library. He was a friend and frequent patron of RS. *c.* 1937.

D Paul Hirsch. Book label to commemorate a disastrous fire in which many of Paul Hirsch's books were damaged. The bibliophile and bookbinder, Douglas Cockerell, repaired some of the more valuable books. 1937.

E Alan Lubbock. Book label. Commissioned by Sir Alan after seeing Philip Gosse's label (*see* 1 C). *c.* 1935.

F Katharine Fortesque. Book label. Date unknown.

G Anne Darlington. Book label. Commissioned by her sister, the singer Esther Darlington, as a gift. 1934–5. *See also* 74 E.

H Richard Jerome. Book label. Date unknown.

I Decorated rule. 1938.

Page 21

Cover design of a chough and illustrations representing the four seasons for a calendar. Commissioned by J. F. Grace, Eton housemaster and lover of Cornwall for the Cornwall County Nursing Association. 1937.

Pages 22 to 24

Illustrations for the illustrated edn. of *The Open Air* by Adrian Bell. Faber & Faber, 1949. *See also* 14 B and D.

Page 25

Headings and illustrations for *Breviarium Romanum*. Commissioned by Stanley Morison for the 1st edn. of the Roman Breviary to be printed in England since the Reformation. Burns & Oates, 1946.

Pages 26 and 27

Chapter headings and tailpiece for Rousseau's *Confessions*. Commissioned by (Sir) Francis Meynell. This edition was based on an anonymous English version of the 18th century. Nonesuch Press, 1938.

Page 28

A–B *Lapidaria*. Title and colophon for the first of a series of personal commonplace books of lapidary inscriptions, collected by John Sparrow, Warden of All Souls College, Oxford. Commissioned by Stanley Morison. The series had by 1976 extended to seven volumes for each of which RS engraved a title and colophon. 1943.

C In Memory of Anthony Evelyn Loveday Schuster. Commemorative book label

for a gift of books to Eton College. 1944.

Page 29

A Ex-dono ab ecclesiis cathedralibus...Commemorative book label. In 1946 the Dean of Winchester, the Very Revd E. G. Selwyn, initiated the English Cathedrals Monte Cassino Fund to help restore the library of the Benedictine monastery at Monte Cassino which had been bombed by the Allies in 1944. All the Benedictine establishments in England and Wales and a number of other institutions collected £1,046 which was sent with the suggestion that the sum might be used to provide new bookshelves. This was commissioned by Dean Selwyn. 1953.

B CEMA. Typographical device for the Council for the Encouragement of Music and the Arts, the predecessor of the Arts Council, set up during the Second World War to keep the Arts alive. 1940s.

C Henry Martineau Fletcher. Commemorative book label. Date unknown.

Pages 30 and 31

Title-page design and chapter-heading illustrations for *Apostate* by Forrest Reid. Faber & Faber, 1947. The author died just after seeing and approving the completed engravings for this autobiography.

Page 32

A Paul Benedict Willis. Book label. Date unknown.

B Eugene M. Ettenberg. Book label. Date unknown.

C Paul McPharlin. Book label. Date unknown.

D Rosamond Wigram. Bookplate. 1930s.

E Ray Livingston Murphy. Book label. 1946.

F Philip Furneaux Jordan. Book label. 1947.

Page 33

A Ex libris E. Clive Rouse, F.S.A., F.R.G.S. Bookplate. Specially designed to incorporate several elements asked for. As a collector of bookplates E. Clive Rouse favoured the 18th-century pictorial style. As an antiquary he wanted an ivy-clad Gothic ruin and trees in a landscape. There is also a rebus used by his namesake, John Rouse, a 15th-century antiquary of Warwick, consisting of a rose enclosing the letter u. 1944–5.

B Gabrielle Woods. Book label. A gift to RS's sister-in-law. 1939.

C Barbara & Nicolas Bentley. Book label. Commissioned at the suggestion of Barnett Freedman. 1930s.

D James Halliday. Book label. Date unknown.

E John Waynflete Carter. Book label. Late 1930s.

Page 34

A Gutenberg. Design for the cover of a catalogue. The Gutenberg Quincentenary Exhibition was to have been held in the Fitzwilliam Museum, Cambridge, in 1940 but as a result of the Second World War it did not take place. This design was commissioned by Brooke Crutchley, Assistant University Printer. 1939.

B–C

Illustrations for *Siegfried's Journey* by Siegfried Sassoon. Faber & Faber, 1945. 34 C was not used. The scenes are of Garsington Manor, former home of Lady Ottoline Morrell. 1944.

D E. libris Roy Murray Hyslop. Bookplate. 1940s.

Page 35

A Arms of Trinity Hall, Cambridge. Commissioned by Brooke Crutchley, Assistant University Printer, on behalf of the Dean, the Revd W. L. S. Fleming. 1938.

B IO Ben. Device. Commissioned by James Wardrop to illustrate an article on Renaissance calligraphy in *Signature*. 1946. *See also* 68 B.

C Nullius in Verba. Arms. Commissioned by Walter Lewis, University Printer at Cambridge, for the Royal Society for use on medal certificates and congratulatory addresses. 1936.

D The Minotaur Press. Device for a small press. 1940s.

E Device for the publisher Rupert Hart-Davis, who took the idea of a fox from David Garnett's *Lady into Fox*. The device is now used by Hart-Davis MacGibbon Ltd. 1946.

F Philip Hofer. Book label. Former Librarian of Houghton Library, Harvard University, USA. 1950.

Page 36

A The Royal Arms to head the Court Circular of *The Times*. The version which appeared as printed on 18 June 1951 was an accurate reproduction of the arms borne in 1785 by George II. The Royal Arms of H.M. Queen Elizabeth II were first used on 23 April 1953, reduced to fit the column width. 1951.

B The Royal Arms in the masthead of *The Times*. 1951.

C Clock device to head the leader page of *The Times*. This version first appeared in the issue of 1 January 1949 but was discontinued from 3 May 1966 when news was printed on the front page for the first time. The current device loosely follows RS's design but the time has been changed to 4.30 to indicate the earlier time of publication. It is interesting to compare the scythe handles. 1948.

D Samuel Knox Cunningham. Bookplate. Commissioned after seeing RS's illustrations for Forrest Reid's *Apostate* (see 30–1). 1948.

E The Royal Arms for the Victoria and Albert Museum publications. It was not until 1953 that the Tudor Crown as shown here was replaced by the St Edward's Crown in all official versions of the Royal Arms. *c.* 1950. *See also* 60 B.

F Arms of the British Council. Designed for use as a letterheading. 1948.

G The Royal Arms used by Eyre & Spottiswoode Ltd, the Royal Printers. 1947.

Page 37

A David Garnett. Bookplate. The writer's motto was derived from one of Blake's *Proverbs of Hell*: 'No bird soars too high if he soars with his own wings', the Latin having a punning reference to pens. 1950.

B FS. Device for the Folio Society Ltd. Commissioned by Charles Eade. 1947.

C Grosvenor, Chater & Co. Ltd. Device. Commissioned by James Shand of the Shenval Press. The design is an adaptation of a trade-mark used since the 19th century. 1949.

D S. Device for Spicer's Ltd. 1947.

E Ex libris Shell. Bookplate. Used by the Shell companies in the late 1940s. 1948.

F The Rampant Lions Press. Device. Commissioned by Will Carter, cousin of RS. 1946.

Page 38

A Desmond Flower. Book label. Designed to be in keeping with a collection of 17th- and 18th-century French books. 1948.

B 16 Bedford Gardens. Letterheading. Commissioned by Ernestine Carter. 1946.

C 5 Thurloe Close. Letterheading. Commissioned by Ellic Howe. 1946.

D William G. Meek. Book label. Date unknown.

E To Ruth. Designed for dedication page of *Printer and Playground* by Oliver Simon. Faber & Faber, 1945.

F Prawls, Stone, Tenterden, Kent. Letterheading. Commissioned by (Sir) George Barnes. *c.* 1946.

G Charles Lucas. Letterheading. 1946–7.

H 110 Heath Street. Letterheading. Date unknown.

I 10 Hertford Street. Letterheading. Commissioned by Robert Harling for Everetts Ltd. 1948.

J John & Alexandrine Russell. Book label. 1948.

Page 39

A AM. Jacket and title-page design for *Prose and Poetry* by Alice Meynell. Jonathan Cape, 1947. Commissioned by her son, Sir Francis Meynell.

B Mary Carter. Book label for RS's cousin. Late 1930s.

C Cambridge University Press. Device. Commissioned for the American branch of the Press. 1951.

D SM. Device for use in various printed items celebrating Stanley Morison's sixtieth birthday. Subsequently used in other publications relating to Stanley Morison. Commissioned by Brooke Crutchley, University Printer at Cambridge. 1947.

E David Low. Letterheading. 1956.

F James Wells. Book label. Later recut in a more austere form with roman capitals. *c.* 1951.

G Keepsake from Reynolds Stone. Lecture prospectus block for a visit to USA. 1969.

Page 40

Chapter-heading designs for *Perseus in the Wind* by Freya Stark. John Murray, 1948.

Page 41

A Title-page design for *A Biographical Dictionary of English Architects, 1660–1840* by Howard M. Colvin. John Murray, 1954.

B Grecian taste and Roman spirit. Heading for the menu cards of the Society of Dilettanti (founded in 1732), incorporating one of the original toasts drunk at the dinners. 1959.

C *Studies in the History of Calligraphy.* Commissioned by Stanley Morison for a series of monographs under this general title. Issued by the Newberry Library, Chicago, and the Harvard College Library. 1949.

D *Luminario.* Title design for a facsimile of a Renaissance book by Giovan Baptista Verini, translated by A. F. Johnson and with an introduction by Stanley Morison. Published in the series *Studies in the History of Calligraphy.* 1946.

Pages 42 and 43

Two illustrations for *The Living Hedge* by Leslie Paul. Faber & Faber, 1946.

Pages 44 and 45

Windsor. Front and back cover design for the *Windsor Official Guide.* Commissioned by Sir Owen Morshead, then Librarian at the Royal Library, Windsor Castle. Now used only for Windsor Castle. 1949.

Page 46

A Letterheading. Commissioned by Villiers David for his brother-in-law's house, Friar Park, near Henley-on-Thames. *c.* 1945.

B Brian Desmond Gallie. Bookplate. Commissioned by a neighbour of RS in Dorset. Date unknown.

C E. & C. Fison. Bookplate. Commissioned by Miss M. G. Hornby for a silver wedding present. The illustration shows the river Stour as seen from the Fisons' house. 1948.

Page 47

Two illustrations for an edition of A. C. Swinburne's poem, *Lucretia Borgia.* Golden Cockerel Press, 1942.

Page 48

A Quoniam Sumus in Vicem Membra. Arms of the United Kingdom Provident Institution. RS introduced by John Benn. 1950.

B The British Council. Christmas card. 1948.

Page 49

The Royal Arms and the arms of the Archbishops of Canterbury and York. Used on the Order of Service for the Coronation of H.M. Queen Elizabeth II. 1953.

Page 50

The Four Gospels. Translated by E. V. Rieu. Gospel headings. Penguin Books, 1952.

Page 51

Hamlet. Jacket design for one of a series of English classics translated into Swedish. Tidens Vorlag, Stockholm, 1954.

Page 52

Alphabet. 1950.

Page 53

A B. Device on jacket and title-page of *Byron: A Self-Portrait. Letters and Diaries 1798–1824* ed. by Peter Quennell. John Murray, 1950.

B–C

Oxford Press | Oxford Books. Two devices for Oxford University Press. 1947.

D Device for the cover of the National Book League's Annual Report. 1949.

E Brooke Crutchley, University Printer. Colophon for the Cambridge University Printer's Christmas book, *Reynolds Stone: His Early Development as an Engraver on Wood,* by J. W. Goodison. The cypress (*Cupressus*) is a rebus of Cambridge University Press. 1947. *See also* 76 B.

F Dolcis. Device. Early 1950s.

G DLT. Device for Darton Longman & Todd Ltd. Commissioned when the publishing house was founded. Of the zodiacal signs of the three founders Libra (the scales) was chosen as being the most distinctive and decorative with the quality of balance. 1959.

Page 54

A Vegetable garden at Litton Cheney with Tom Pile, the gardener, and church tower beyond. Unpublished. 1953.

B Ruin with three children. Unpublished. *c.* 1960.

C Wild orchard at Litton Cheney. From the series, *The Old Rectory,* published by Warren Editions (Jonathan & Phillida Gili) in an edition of 150 copies. 1976.

Page 55

A Cedar of Lebanon. Device. Commissioned by John Gill, tree consultant, Axminster. Drawn at Mary Clive's house, Whitfield, in Herefordshire. 1970.

B Fox under tree. Design for the cover of the

autumn issue of the *Countryman*. One of a series of engravings by different artists. 1961.

c RS's daughter reading in Litton Cheney garden. *See* 54 c.

Page 56

Dedication page. Commissioned by Sir Francis Meynell for a new edition of *Shakespeare's Poems* to coincide with the Coronation of H.M. Queen Elizabeth II. Nonesuch Press, 1953. 1952.

Page 57

A Sandringham Library. Book label. *c.* 1960.

B Coppins, Iver, Buckinghamshire. Book-plate for H.R.H. The Duchess of Kent. 1962.

Pages 58 and 59

Samples of Minerva type. In 1953 Linotype & Machinery Ltd issued, under the name 'Pilgrim', the Bunyan typeface created by Eric Gill for use in the private press conducted by Gill and René Hague. As a book type the design was excellent in the sizes for which it was designed (8–14 pt.) but would clearly not respond very well to being made in larger sizes. It occurred to Linotype that it would be useful to invite a designer to produce a type meant for display sizes which, though not derived from Bunyan, would work well in company with the text sizes. RS was commissioned by Linotype to design the face, which was introduced to the public in *Linotype Matrix*, No. 21, January 1955. It was discontinued in the early 1970s. 1954.

Page 60

A Abridged Royal Arms without supporters or motto. Designed for HMSO to use where a device less emphatic than the Royal Arms is required. It is used in various sizes. 1956.

B The Royal Arms. Commissioned by HMSO. Approved by H.M. Queen Elizabeth II in January 1956 and by Commons and Lords for use in Hansard in April 1956. In 1953 H.M. The Queen had expressed the wish that the representation of the Tudor Crown should be replaced in all official designs by the St Edward's Crown, the one actually used at the Coronation. Also, development in printing processes and improvement in layout of Government publications since 1924, when Kruger Gray's version of the Royal Arms

had been adopted, made it necessary to use a design which would be more adaptable to reproduction in small sizes and would also have a more modern appearance. 1955.

c Royal emblem (crown with decorative rose, thistle, shamrock and leek). It is used by HMSO as an alternative to Abridged Royal Arms. 1956.

Pages 61 to 64

Boxwood. At the suggestion of Ruari McLean some unpublished wood engravings by RS were used by the Monotype Corporation to decorate the showing of their Dante type designed by Giovanni Mardersteig (the type in which this book is set). Poems by Sylvia Townsend Warner, inspired by the engravings, form the text and the book was published under the title *Boxwood* in 1957. For the trade edition of this book, *see* 95 B.

Page 65

The Reynard Library. Series cover design for volumes containing the works of great English and Scottish writers, mainly poets. Commissioned by (Sir) Rupert Hart-Davis. 1950.

Pages 66 and 67

Illustrations for *A Sociable Plover and Other Stories* by Eric Linklater. Rupert Hart-Davis, 1957.

Page 68

A David Cooper. Book label. 1948.

B *Signature*. Title design for a magazine on printing and the graphic arts, founded, edited and printed by Oliver Simon at the Curwen Press. Number 2 (March 1936) contained a critical article, 'The Woodcut Calligraphy of Reynolds Stone', by John Carter.

c Lancelot Dykes Spicer. Book label. 1952.

D Anthony Furse. Book label. 1960.

Page 69

Alphabet. Unpublished. 1953.

Page 70

Periodical. Cover illustrations representing the four seasons for a quarterly list of books published by Oxford University Press, 1959.

Page 71

Commemorative mug designs. Commissioned by Herbert Simon to mark Sir Francis Meynell's seventieth birthday. The

designs were transferred to the mugs by students at the Department of Ceramics, Royal College of Art, 1961.

Page 72

The Gospel as recorded by Mark. Title-page for a privately printed edition of part of E. V. Rieu's translation of the New Testament. It was distributed by Sir Allen and Richard Lane as a Christmas present. Printed at the Curwen Press, 1951.

Page 73

Illustrations for an adventure story. Date unknown.

Page 74

A CRS. Book label for RS's uncle, Christopher Stone. After distinguished war service he became well known as the first disc-jockey in the 1930s.

B 31a Connaught Street. Letterheading. Cut for RS's sister, Mrs Peter Gaynor. 1930s.

C Violet Ashby. Book label. Late 1930s.

D George Clive. Bookplate. Whitfield House, Herefordshire. Given to George Clive as a present by a group of friends. 1962.

E Esther Darlington. Book label. Since Miss Darlington is a professional singer, the music is taken from *An Evening Hymn on a ground by Henry Purcell*; the words are by Dr William Fuller, Bishop of London. 1948. *See also* 20 G.

Page 75

A Bibliotheca Broxbourniana. Book label. Commissioned by Mr and Mrs Albert Ehrman for the gift to their son John of the early printed books in their library. 1949.

B Arnold Muirhead. Book label. Commissioned by the antiquarian bookseller for his personal library. He used it in three colours: brown for 17th- and 18th-century books bound in calf; and blue and black for more recent books. *c.* 1946.

C Snape Hall. Letterheading. For Mr and Mrs R. A. Harrison. The commission was given after seeing an exhibition at the Aldeburgh Festival. 1953.

D ILAB. Book label. Designed for the International League of Antiquarian Booksellers, but not used. *c.* 1950.

E Johannis et Hyacinthae Lawrence. Book label. Sir John Lawrence Bt commissioned this label soon after the Second World War when he inherited a large number of

books in several languages from five generations of ancestors. *c.* 1947.

Page 76

A Repeat cover design for a series of pamphlets entitled *Cambridge Printers' and Authors' Guides.* Cambridge University Press, 1950.

B Repeat graver design. Commissioned by Brooke Crutchley for a book, *Reynolds Stone: His Early Development as an Engraver on Wood*, by J. W. Goodison, privately printed at Cambridge, as the first in a series of Christmas books presented by the University Printer. 1947. *See also* 53 E.

C Repeat primrose design. 1960s. *See* 54 C.

Page 77

Jacket and title-page design for *From Darkness to Light* by Victor Gollancz. Only the top part was published. Victor Gollancz, 1956.

Page 78

A Pekin duck, Aylesbury duck, Roman goose. Business letterheading design. Commissioned by the Honourable Mrs John Betjeman when she started The Mead Waterfowl Farm in 1951–2.

B Arms of Aldeburgh. Commissioned by Benjamin Britten (Lord Britten) and Peter Pears for the Aldeburgh Festival programme. 1958.

C E. libris Stanhope Shelton. Book label. The rebus of shell and tun has a family origin and is to be seen in windows of two Norfolk churches in a different form. Date unknown. *See also* 100 D.

Page 79

A St Francis with birds and wolf. Cover design for *The Little Flowers of St Francis.* Penguin Books, 1959.

B Michael Sadleir Collection. Book label for a famous collection of Victorian yellow-backs, acquired in 1952 by Lawrence Clark Powell for the University of California. 1953. *See also* 1 B.

C 3d postage stamp. Design to mark the British Empire and Commonwealth Games, 1958. Printed purple.

D The Friends of the Tate Gallery. Design commissioned for use in ephemeral publications. 1959.

E Man and sundial. Device for a private press, The Mill House Press. Commissioned by

the Honourable Robert Gathorne-Hardy. *c.* 1948.

Page 80

Caroli Guglielmi Brodribb. Memorial inscription to a member of *The Times* staff inside the Brodribb bible at All-Hallows-by-the-Tower. Commissioned by Stanley Morison. 1947.

Page 81

Alphabet. Engraved for RS's private typefount, Janet. Used in the Litton Cheney Press. 1958.

Pages 82 *and* 83

Decorations for a special edition of *Sonnets from the Portuguese* by Elizabeth Barrett Browning. Folio Society, 1962.

Page 84

A Ashmansworth Church, Berkshire. Christmas card drawn by RS in the orchard of the composer Gerald Finzi. After her husband's death in 1956, Mrs Joy Finzi purchased the engraving for use as a bookplate and on the folder of information for Laurence Whistler's little engraved window in the church porch. RS also cut the memorial stone to Gerald Finzi beside the porch. 1948.

B Castle of Tarasp, Switzerland. Engraved for Prince Ludovic and Princess Margaret of Hesse and the Rhine after the Stones' visit to them. 1953–4.

C The Old Rectory, Litton Cheney. *See* 54 C.

Page 85

A Girl in snow landscape. Unpublished. 1950s.

B Sketcher working at edge of wood. *c.* 1960. From prospectus for *The Old Rectory. See* 54 C.

C Jacket design for Johnson's *Journey to the Western Islands of Scotland* and Boswell's *Journal of a Tour to the Hebrides with Samuel Johnson, LL.D.*, ed. by R. W. Chapman. Oxford University Press, 1964.

Page 86

A Farmleigh. Book label. Commissioned by the Earl of Iveagh. 1969. *See also* 145 B.

B Roger Wood. Book label. Date unknown.

C John C. Tarr. Book label. *c.* 1934.

D Walter A. Frankel. Book label. The names allowed unbroken flourishes. 1967.

E David H. E. Wainwright. Book label. Date unknown.

F To Raoul Curiel. Dedication tablet for

Glossary of the Book by G. A. Glaister, a book on printing techniques. Allen & Unwin, 1960.

G J. R. Abbey. Book label. For the book collector. 1960.

H Donald & Mary Hyde. Book label. Commissioned for the Hydes' collection of Johnsoniana, the Four Oaks Library, whose name is suggested in a rebus depicting leaves of the pin oak (*Quercus palustris*). 1965.

Page 87

A Barclays Bank Directors Library. Bookplate. *c.* 1953.

B The Advertising Association. Bookplate. Commissioned for the Association's Library of Advertising, which had recently been established for the use of members, researchers, journalists and students. 1955.

Pages 88 *and* 89

Title-pages for *The Typographic Book, 1450–1935* by Stanley Morison and Kenneth Day. Ernest Benn, 1963.

Page 90

Illustrations for *The Skylark and Other Poems* by Ralph Hodgson. Printed for Colin Fenton and distributed by Rupert Hart-Davis, 1958.

Page 91

Dorset landscape near Litton Cheney. 1960s. *See* 54 C.

Page 92

I Vangeli. One of the title-pages for an edition of the Gospels published in English, Latin and Italian versions by Giovanni Mardersteig at the Officina Bodoni, Verona, 1962.

Page 93

A Cover design for the *Chichester Cathedral Journal.* Commissioned by the Dean, the Very Revd Walter Hussey. 1958.

B, D

Alternative designs for the jacket of the New English Bible. 93 B was not used; 93 D was used on the jacket. Oxford and Cambridge University Presses, 1961.

C Chi-Rho. Cover design for *Theology.* Commissioned by Professor G. R. Dunstan when appointed editor. First published, S.P.C.K., 1964.

E St Michael slaying seven-headed snake. Badge of Coventry Cathedral. Commissioned at the request of the Bishop

of Coventry for the title-page of the Order of Service for the consecration of the new cathedral in 1962. Above St Michael are the Mercian Cross and four other Crosses depicting the Coventry Cross of Nails. The Coventry Cross was formed from nails fallen from the roof of the old cathedral when it was destroyed by incendiary bombs in 1940.

Page 94

Two illustrations for *Tribute to Benjamin Britten on his Fiftieth Birthday*, edited by Anthony Gishford. It contained contributions by his friends. Faber & Faber, 1963.

Page 95

A Cygnet. Device for the Cygnet Press, Burford. 1975.

B *Boxwood*. One of the additional illustrations for the trade edition of the Monotype Corporation's original publication (*see* 61–4). Chatto & Windus, 1960. Scotney Castle is near Lamberhurst in Kent.

C Rosemary. Engraving. Commissioned by Walter Oakeshott for a Christmas card which he had printed by Cambridge University Press in 1949. At his request it was incorporated in a limited edition of his anthology, *The Sword of the Spirit*, which was produced for the use of the boys at Winchester College, of which Walter Oakeshott was Headmaster. The illustration refers to the quotation of Sir Thomas More's which runs: 'As for rosemary, I let it run all over my garden walls, not onlie because my bees love it, but because it is a herb sacred to remembrance and to friendship, whence a sprig of it hath a dumb language.' Faber & Faber, 1950.

Page 96

A Hugh Lyle. Bookplate. Late 1950s.

B Eleanor, (Countess of) Castle Stewart. Bookplate. Commissioned by the Earl of Castle Stewart to give to his wife. The woodpecker was a frequent visitor to their bird-table. 1964.

C (Lady) Caroline Gilmour. Book label. 1950.

Page 97

A Barbara (Countess of) Moray. Book label. Late 1950s.

B Oswald Constantine John, Marquis of Normanby. Bookplate. 1954.

Page 98

A Jacket design for *Traherne: Poems, Centuries and Three Thanksgivings*. Oxford University Press, 1966.

B–C Illustrations for *The Italian Girl* by Iris Murdoch. Chatto & Windus, 1964.

Page 99

A Kingston Russell House. Letterheading. Commissioned by Mrs William Vestey. Kingston Russell House was the birthplace of Admiral Hardy, the friend of Admiral Nelson. It was allowed to become a ruin but was restored in 1913. 1955–6. *See also* 101 F.

B Garden at Litton Cheney. 1960. *See* 54 C.

Page 100

A Andrea Bocca. Book label. Commissioned through the antiquarian bookseller Henry Davis (*see* 121 C) for a Torinese count. 1964.

B Emma Tennant. Book label. Given by RS to Lady Emma Tennant as a wedding present. The flowers and leaves reflect her botanical interests. 1963.

C B. Y. McPeake. Book label. Early 1960s.

D Woodcote End House. Letterheading. Commissioned by Stanhope Shelton. 1960. *See also* 78 C.

E Peter Summers, F.S.A. Bookplate. Design relates to Peter Summers's work of producing a detailed record of all surviving hatchments in Britain. 1961.

F Goose on book with initials J.M. Device for Goose & Son (Publishers), Norwich. The initials are those of the Managing Director, John Moore. Commissioned for the first book published in the list, *The Development of the English Traction Engine* by Ronald H. Clark, 1960. RS was introduced through Michael Oliver of Jarrolds. 1959.

Page 101

A 20 Montpelier Villas, Brighton. Letterheading. Commissioned by Gilbert Harding, the broadcaster. *c.* 1957.

B 12 Church Street, Aylesbury. Letterheading. Commissioned by Elliott Viney of Hazell, Watson & Viney. 1950.

C Green End House, Aylesbury. Letterheading. Commissioned by Elliott Viney. 1953.

D Kilham House, Mindrum. Letterheading. Commissioned by Mr and Mrs David Mosse. 1962.

E Swyre Old Rectory, Dorchester. Letter-heading. A Christmas present from RS to Mr and Mrs John Hubbard when they first moved in. 1961.

F Kingston Russell House, Long Bredy. Letterheading for Mrs William Vestey. 1965. *See also* 99 A.

G The Clock House, Keele. Letterheading. Commissioned by Sir George Barnes when he became Principal of the University College of North Staffordshire (now the University of Keele). 1956.

Page 102

A College of Librarianship, Wales. The Appleton Collection. Book label. Commissioned by the antiquarian bookseller Tony Appleton and presented to the College for his collection of 19th-century colour printing and publishers' bindings, purchased by the College as a special working collection for students of book production. 1973.

B National Trust. Book label. Date unknown.

C Ex libris Peter John Mold. Book label. Commissioned by the Precentor of Perth Cathedral, Western Australia, after seeing the Eton College Library label. 1970.

Page 103

A Stephen Middleton. Bookplate. 1950.

B University Library, Liverpool. Bookplate. 1948.

Page 104

A Robert Elwell. Book label. 1965.

B Alfred Fairbank. Title-page design for *Calligraphy and Palaeography: Essays Presented to Alfred Fairbank* to celebrate his seventieth birthday. Faber & Faber, 1965.

C Kate & John Gilmore. Book label. Not used. 1964.

Page 105

A John Sparrow. Book label. Commissioned by the Warden of All Souls College, Oxford. *c.* 1950.

B R. Shaw-Kennedy. Book label. *c.* 1960.

C Simon Ridley. Book label. Date unknown.

D Peter Tiarks. Book label. 1961.

E Richard E. Deems. Book label. Early 1960s.

F Morton D. Zabel. Book label. Date unknown.

G David Hellings. Book label. 1950s.

Pages 106 *to* 111

Illustrations for *Omoo* by Herman Melville. Engraved by RS for the edition of *Omoo*, published for its members by the Limited Editions Club, copyright © 1961.

Page 112

A Francis Meynell. Title-page design for *Two Poems* by Sir Francis Meynell. Printed in a limited edition as a gift for his seventieth birthday from Douglas Cleverdon, Brooke Crutchley, John Dreyfus, Stanley Morison, Vivian Ridler and Reynolds Stone. Booklet printed at the Cambridge University Press. 1961.

B Arthur Penn. Book label. *c.* 1960.

C Duncan Guthrie. Book label. 1960s.

D Oliver Millar. Book label. *c.* 1963.

E Richard M. Coode. Book label. 1969.

F Charles W. Hobson. Book label. Date unknown.

Page 113

A Mary Keswick. Book label. *c.* 1960.

B Franklin Gilliam. Book label. 1958.

C Colin Fenton. Book label. 1956–7.

D Gloria Abbey. Book label. 1969.

E Stuart B. Schimmel. Book label. 1959.

F Simone & David Sekers. Book label. 1965.

Pages 114 *and* 115

Four illustrations for *Two Stories* by T. F. Powys. R. A. Brimmell, Hastings, 1967.

Page 116

A–B

Printing and the Mind of Man. Title-block and illustration for catalogue of IPEX '63, an exhibition of printing equipment and other related material. The illustration shows Gutenberg's basic invention, the type-mould surrounded by the movable types it casts. The exhibition was arranged by F. W. Bridges & Sons Ltd and the Association of British Manufacturers of Printing Machinery (Pty) Ltd. *See also* 118–119.

C Device for Oxford University Press. Commissioned by the Printer to the University. Three possible ways of treating the motto are shown. The Press felt bound to follow the traditional arrangement in the right-hand shield. 1955.

Page 117

Guildhall Banquet cover. This new version of the arms of the City of London

was commissioned by Sir Gilbert Inglefield at the beginning of his term of office as Lord Mayor and was used on all banquet menus during the year of his mayoralty. 1967.

Pages 118 and 119
Printing and the Mind of Man. Title-pages of the book, arising from the IPEX '63 exhibition (*see* 116 A–B), edited by John Carter and Percy H. Muir. Cassell, 1967.

Page 120
A Gryphon with book. Device of John Murray (Publishers) Ltd. A simplified version of the arms of John Murray. 1959.
B Kingfisher. Device. Commissioned by John Carter for a series of booklets published by the Halcyon-Commonwealth Foundation under the imprint, Halcyon Press; first booklet published in 1964. 1963.
C Beaver holding book. Device of Blackwell's Bookshop, Oxford. Commissioned by Sir Basil Blackwell, who states: 'It is the crest which I wear on my helmet when I go jousting, and it symbolises certain aspects of myself viewed *ideally* – to wit, the virtues of diligence and constructiveness, delight in swimming in all seasons and, I believe, good humour.' 1963.
D Bear with staff. Device for the title-page of *Milton: Complete Poetry and Selected Prose*, edited by E. H. Visiak. Nonesuch Press, 1938. This device was reproduced on the jacket of Sir Francis Meynell's autobiography, *My Lives*, published by The Bodley Head, 1971.
E hh, oak tree and book. Device of Hamish Hamilton Ltd. First used in the twenty-first anniversary volume, *Majority*, 1952. 1951.
F Dolphin and anchor. Device of J. M. Dent & Sons Ltd. When J. M. Dent started as a publisher he adopted the dolphin and anchor from Aldus Manutius, founder of the Aldine Press in Venice in the 1490s. RS's version was adopted in 1952.

Page 121
A Harold William Bradfield, Bishop of Bath & Wells. Book label. Commissioned by Mrs Elizabeth Bradfield for her late husband's books, some of which were given to his friends and the rest to King's College, London. 1960.

B Department of the History of Art, Oxford. Book label. Commissioned by Professor Edgar Wind. 1967.
C The Henry Davis Collection. Book label. Commissioned by the antiquarian bookseller Henry Davis for two collections: one of bookbindings of all periods, which he gave to the British Library; another of early printed books given to the New University of Ulster, Coleraine. The labels were printed in two sizes and in two colours, black and maroon. 1968.
D Eton College Library. Bookplate. Commissioned by John Carter and Patrick Strong, Keeper of the College Library and Collections, to mark the restoration of the Library. 1969.

Page 122
A *The Circle of Knowledge.* Title-block. Commissioned by James Wells for the cover and title-page of an exhibition catalogue. The exhibition was held by the Newberry Library, Chicago, to commemorate the 200th anniversary of the *Encylopaedia Britannica*. 1968.
B Stanley Morison. Dedication for the catalogue of 'The Circle of Knowledge' exhibition. Stanley Morison had recently died and both exhibition and catalogue were dedicated to him. 1968.

Page 123
A Thistle|1768. Colophon. Designed for Encyclopaedia Britannica International Ltd for their bicentenary. 1968.
B–J
Senator William Benton. Designs. Commissioned by Stanley Morison for a gift to mark the sixty-fifth birthday of Senator William Benton, the chairman and publisher of the *Encyclopaedia Britannica*. The gift was a small card box containing loose printed leaves recording emblems of significant stages in the Senator's life: (B) monogram of Benton & Bowles (Advertising) Inc; (C) Merriam-Webster; (D) decorative border; (E) loon, State emblem of Minnesota; (F) Helen Hemingway, the Senator's wife; (G) Senatorial badge of Connecticut; (H) repeat pattern on box; (I) arms of Yale University: editor of *Yale Record*; (J) arms of the University of Chicago. 1965.

Pages 124 *and* 125

Tit for Tat. Five illustrations for a collection of songs by Benjamin Britten (Lord Britten), Faber Music, 1969.

Pages 126 *to* 131

Saint Thomas Aquinas. A selection of illustrations and headings for a special volume of his works edited by George N. Schuster, published for its members by the Limited Editions Club, copyright © 1971.

Page 132

A Arms of Cambridge University Press surrounded by oak leaves. *c.* 1967.

B FIDE. Arms of Reed's School, Cobham, Surrey. 1970.

C God Grant Grace. Arms of the Worshipful Company of Grocers. Commissioned by Elliott Viney during his Mastership. Grocers' Hall was almost completely destroyed by fire in September 1965. The new hall, the fifth to be built on the same site, was opened in 1970. RS was asked to make his design in keeping with the contemporary style of the new hall. Used on the cover of Livery Dinner programmes. 1970.

Page 133

A St Louis Priory School Library. Book label. Commissioned for the Benedictine monastery in St Louis, Missouri, founded from Ampleforth Abbey, York, in 1955. The founders remembered RS's work from their days in England. *c.* 1958.

B The John Lane Bequest. Bookplate. Commissioned by Allen and Richard Lane in memory of their brother John killed in action in 1942. The Bequest was a gift of money to the Red Cross in Victoria, Australia, with the suggestion that the interest be spent on buying books with a nautical connection for hospital distribution. The commission was arranged through Hans Schmoller. The ship portrays the type of English vessel that faced the Armada, to quote RS, 'without too much top-hamper, lying low and snug in the water, faster and more weatherly than the larger and more heavily armed Spaniard'. 1966.

C Princeton University Library. Bookplate. Commissioned by P. J. Conkwright,

typographer of Princeton University Press. 1970.

D Un livre est un ami qui ne change jamais. Book label. Commissioned for a collection of books in the Bodleian Library, Oxford, relating to Samuel Johnson and his circle. The collection was initiated by Mrs Mary Hyde (*see* 86 H) as a tribute to the Johnsonian scholar Dr Lawrence Fitzroy Powell. 1970.

Page 134

A Illustration for the title-page of *Riding to the Tigris* by Freya Stark. John Murray, 1959.

B Illustration for the title-page of *Ionia: A Quest* by Freya Stark. John Murray, 1954.

C Illustration for the title-page of *Alexander's Path* by Freya Stark. John Murray, 1958.

D Illustration for the title-page of *The Lycian Shore* by Freya Stark. John Murray, 1956. The ship is a polacre.

Page 135

A Tree. Unpublished. Date unknown.

B Snow landscape inspired by winter 1962–3. The hedges have since been rooted out. *c.* 1967. *See* 54 C.

C Trees on edge of downland near Litton Cheney in west Dorset. Unpublished. Date unknown.

Page 136

A Peter Pears & Benjamin Britten. Bookplate. Commissioned by Benjamin Britten (Lord Britten). 1970.

B Iain Bain. Bookplate. The words 'Homage to TB' were included at RS's suggestion to reflect a shared admiration of the wood engraver Thomas Bewick. 1970.

Page 137

A Michael Cary. Book label. Commissioned at the suggestion of John Carter and printed in four different colours. 1971.

B Douglas C. Ewing. Book label. 1970.

C Hugh Gibson. Book label. 1970.

D H. F. Norman, M.D. Book label. 1973.

E Richard Little Purdy. Book label. 1971.

F John Murray. Device. Commissioned by John G. Murray for the firm's bicentenary in 1968.

Page 138

Hart's tongues. Many of RS's watercolours are done with engravings in mind. This subject was originally a watercolour. 1971. *See* 54 C.

Page 139

A Litton Cheney garden with pheasant. RS's family Christmas card. 1970. *See* 54 C.
B Waterfall. Unpublished. 1970s.

Page 140

A Jonathan & Phillida Gili. Bookplate for RS's daughter and son-in-law. 1971.
B Walter & Mary Hamady. Book label. Commissioned for use with their private press (*see* 140 C). 1972.
C The Perishable Press Ltd. Device for the private press of Walter and Mary Hamady, Mount Horeb, Wisconsin, USA. 1971.
D Susan Woulfe Crawshaw. Bookplate. 1973.

Page 141

A Arms of Verona. Engraved for a book presented to Giovanni Mardersteig to celebrate his eightieth birthday. *See also* 92.
B Royal Institute of Navigation. RS first designed the Institute's emblem in 1951. He cut this new engraving in 1971 when the Institute became the Royal Institute. The bird is an Arctic tern, a creature with a remarkable facility for navigation.
C C. W. Dilke. Book label. Commissioned by Mrs Dilke as a birthday present for her husband. The dove is a more naturalistic version of the family crest; the oak leaves reflect the old oak forest in which the Dilkes' house stands. 1973.

Page 142

A Ruined cottage. Unpublished. *c.* 1956.
B Biddesden House, near Andover. Commissioned by Lord Moyne for a postcard. 1960.

Page 143

Three illustrations for *The Other Side of the Alde* by Kenneth Clark. Printed in a limited edition at Litton Cheney and published by Warren Editions (Jonathan and Phillida Gili). 1968.

Page 144

A Peter & Kathleen Wick. Book label. Commissioned by the Curator of Printing and Graphic Arts at the Houghton Library, Harvard, USA. 1970.
B Joan Feisenberger. Book label. Designed for a collection of books about cats, comprising mainly 19th-century children's books. 1972.

C (Sir) Ivison Macadam. Bookplate. 1972.
D James Stourton. Book label. Commissioned when he was at Ampleforth College. 1972.
E Jenni Orme. Book label. RS's present to his future daughter-in-law on her twenty-first birthday. 1971.

Page 145

A John Harris. Bookplate for the Librarian of the Royal Institute of British Architects. A present from his wife. 1971.
B Earl of Iveagh. Bookplate. The background to the arms was kept dark by RS to show off the heraldry and hint at a wild Irish landscape. 1973.

Page 146

Two illustrations for a projected edition of Thomas Love Peacock's *Crotchet Castle* to be printed at the Stamperia Valdonega, but which has been indefinitely postponed. Commissioned by David R. Godine. 1970.

Page 147

A Jacket and frontispiece illustration for *Another Self* by James Lees-Milne. Hamish Hamilton, 1970.
B Letterheading. Engraved for Derek Hill from RS's watercolour of his house in Ireland. 1970.

Pages 148 and 149

Charles, Prince of Wales|Tywysog Cymru. Book label and the Royal Arms. 1970.

Page 150

Two illustrations for *Moments of Vision* by Kenneth Clark. John Murray, 1973. Printed and bound specially for Lord Clark's seventieth birthday.

Page 151

A Seashore. Inspired by Tennyson's 'Break, break, break . . .' Unpublished. Mid 1970s.
B Sycamore. 1973.
C Crossing the bar. Illustration for *Poems of Alfred, Lord Tennyson*, selected and introduced by John D. Rosenberg, published for its members by the Limited Editions Club, copyright © 1974.

Page 152

Floral decorated rule and borders.

ACKNOWLEDGEMENTS

Grateful acknowledgement is given to all Reynolds Stone's patrons for their kindness in agreeing to the reproduction of engravings:
By gracious permission of Her Majesty The Queen, 12 A, 49, 57 A
By gracious permission of Her Majesty Queen Elizabeth The Queen Mother, 4 C
By gracious permission of H.R.H. The Prince of Wales, 148–9
By gracious permission of H.R.H. The Duke of Kent, 57 B

Miss Gloria Abbey, 113 D
Advertising Association, 87 B
Aldeburgh Festival Committee, 78 B
Mrs Rosemary Armour, 2 B
Courtesy of the Arts Council, 29 B

Mr Iain Bain, 136 B
Barclays Bank Ltd, 87 A
Lady Barnes, 10 B, 38 F, 101 G
Ernest Benn Ltd, 88–9
Mr and Mrs Nicolas Bentley, 33 C
The Honourable Mrs John Betjeman, 78 A
Bibliothèque Nationale, 8 D
Sir Basil Blackwell, 120 C
Signora Andrea Bocca, 100 A
The Curators of the Bodleian Library, 133 D
Mrs Elizabeth Bradfield, 121 A
Mr R. A. Brimmell, 114–15
British Council, 36 F, 48 B
Mr Conant Brodribb, 80
B.S.C. Footwear Ltd, 53 F
Burns & Oates Ltd, 25

Cambridge University Press, 6–7, 13 B, 28 A–B, 39 C, 76 A, 93 B,D, 112 A, 132 A
University Printer at Cambridge, 4 A, 34 A, 39 D, 53 E, 76 B
Mrs O. G. Cameron, 20 G
Jonathan Cape Ltd, 39 A
Mrs Ernestine Carter, 38 B
Mr Will Carter, 33 E, 39 B
Sir Michael Cary, 137 A

Eleanor, Countess of Castle Stewart, 96 B
Chatto & Windus Ltd, 95 B, 98 B–C
By kind permission of the Dean of Chichester, 93 A
Mr George Clive, 74 D
College of Librarianship, Wales, 102 A
Mr David Cooper, 68 A
Countryman, 55 B
The Provost of Coventry, 93 E
Mrs Susan Woulfe Crawshaw, 140 D
Sir Samuel Knox Cunningham, 36 D
The Curwen Press Ltd, 68 B

Miss Esther Darlington, 74 E
Darton, Longman & Todd Ltd, 53 G
Mr Villiers David, 46 A
Mr Henry Davis, 121 C
Mr Richard E. Deems, 105 E
J. M. Dent & Sons Ltd, 120 F
Mr C. W. Dilke, 141 C
Double Crown Club, 8 B

Mr John Ehrman, 75 A
Encyclopaedia Britannica, 123
Epicure Holdings Ltd, 10 A
By kind permission of the Provost and Fellows of Eton College, 13 E, 28 C, 121 D
Mr Eugene M. Ettenberg, 32 B
Everetts Ltd, 38 I
Mr Douglas C. Ewing, 137 B
Eyre & Spottiswoode Ltd, 36 G

Faber & Faber Ltd, 8 A, 14, 22–4, 30–1, 34 B–C, 38 E, 42–3, 94, 104 B, 124–5
Mr Alfred Fairbank, 104 B
Mrs Joan Feisenberger, 144 B
Mr Colin Fenton, 90, 113 C
Mrs Joy Finzi, 84 A
Lady Fison, 46 C
Dr Desmond Flower, 38 A
Folio Society Ltd., 37 B, 82–3
Francis Holland School, 11 D
Friends of the Tate Gallery, 79 D
Mr Anthony Furse, 68 D

Mr David Garnett, 37 A
Mrs Peter Gaynor, 74 B
Mr Hugh Gibson, 137 C
Jonathan and Phillida Gili, 140 A
Mr John Gill, 55 A
Lady Caroline Gilmour, 96 C
Mr G. A. Glaister and Allen & Unwin Ltd, 86 F
Mr David R. Godine, 146
Victor Gollancz Ltd, 77
Goose & Son Ltd, 100 F
Grosvenor, Chater & Co. Ltd, 37 C

Halcyon-Commonwealth Foundation, 120 B
Mr and Mrs Walter Hamady and Perishable Press Ltd, 140 B–C
Hamish Hamilton Ltd, 120 E, 147 A
Mr John Harris, 145 A
Mr R. A. Harrison, 75 C
Hart-Davis, MacGibbon Ltd, 35 E, 65–7
Reproduced by permission of the Controller of Her Majesty's Stationery Office, 60
Mr Derek Hill, 147 B
Mr R. P. Hirsch, 20 D
Mr Philip Hofer, 35 F
Mrs John Holroyd-Reece, 9 F
Mr Ellic Howe, 38 C
Mr and Mrs John Hubbard, 101 E
Mrs Mary Hyde, 86 H

Sir Gilbert Inglefield, 117
The Earl of Iveagh, 86 A, 145 B

Mr Robert Furneaux Jordan, 32 F

Sir William and Lady Mary Keswick, 113 A

Lady Manners School, 4 B
Sir John Lawrence, 75 E
By permission of the Limited Editions Club Inc, Westport, Connecticut, USA, 106–11, 126–31, 151 C
Linotype-Paul Ltd, 58–9
David Low Booksellers Ltd, 39 E
Sir Alan Lubbock, 20 E
Mr Charles Lucas, 38 G

Miss Alta Macadam, 144 C
Mr B. Y. McPeake, 100 C
Mrs Paul McPharlin, 32 C
Dr Giovanni Mardersteig, 92, 141 A
Princess Margaret of Hesse and the Rhine, 84 B

Dame Alix Meynell, 71
Sir Stephen Middleton, 103 A
Sir Oliver Millar, 112 D
Revd Peter John Mold, 102 C
Mrs Diana Money, 3 D
Monotype Corporation Ltd, 61–4
Barbara, Countess of Moray, 97 A
Mr David Mosse, 101 D
Lord Moyne, 142 B
Mr Arnold Muirhead, 75 B

National Book League, 53 D
By permission of the National Postal Museum, London, 79 C
National Trust, 102 B
By kind permission of the Newberry Library, Chicago, 41 C–D, 122
Nonesuch Press Ltd, 1 D, 5, 26–7, 56, 120 D
Dr H. F. Norman, 137 D
The Marquis of Normanby, 97 B

Mr Walter Oakeshott, 95 C
Miss Armide Oppé, 1 A
Organisers of the 'Printing and the Mind of Man' exhibition (1963) and Cassell & Co. Ltd, 116 A–B, 118–19
Oxford University Press, 53 B–C, 70, 85 C, 93 B,D, 98 A, 116 C

Mr Peter Pears, 136 A
Penguin Books Ltd, 50, 72, 79 A, 133 B
Mrs Gabrielle Pike, 33 B
Princeton University Library, 133 C
Mr Jocelyn Proby, 10 D
Professor Richard Little Purdy, 137 E

Rampant Lions Press, 37 F
Reed's School, 132 B
Mr Simon Rendall, 95 A
Mr E. Clive Rouse, 33 A
Royal Institute of Navigation, 141 B
By kind permission of The Royal Society, 35 C

Mr Richard Sadler, 1 B
St Louis Priory School, 133 A
Mlle Suzanne de Saint-Mathurin, 9 E
Mr Stuart B. Schimmel, 113 E
Mr and Mrs David Sekers, 113 F
Mr Ronald Shaw-Kennedy, 105 B
Shell Printing Ltd, 37 E
Mr Stanhope Shelton, 78 C, 100 D

ACKNOWLEDGEMENTS

Society for Promoting Christian Knowledge, 93 C
Society of Dilettanti, 41 B
Mr John Sparrow, 105 A
Mr Lancelot Dykes Spicer, 68 C
Spicer's Ltd, 37 D
Squire Law Library, 12 C
Mr and Mrs Paul Standard, 2 D–E
Mrs Jenni Stone, 144 E
Mr Reynolds Stone, 2 F, 3 A–B, 11 B–C, 13 A, C–D, 39 G, 54 A–B, 69, 73, 74 A, 75 D, 81, 85 A, 135 A, C, 139 B, 142 A, 151 A
The Honourable James Stourton, 144 D
Mr Peter Summers, 100 E

Mr John C. Tarr, 86 C
Bernhard Tauchnitz Verlag GmbH, 8 E–F
Lady Emma Tennant, 100 B
Miss Nancy Tennant, 9 D
Lady Diana Tiarks, 105 D
Tidens Vorlag, 51
The Times, 36 A–C
The Master and Fellows of Trinity Hall, 35 A
Typophiles Society, 20 A–B

United Kingdom Provident Institution, 48 A
Curator of Rare Books, University of California, 79 B
By kind permission of the Librarian, University of Liverpool, 103 B
University of Wales, 10 E–G, 15–17

Mrs Urla Vestey, 101 F
Victoria and Albert Museum, 36 E
Mr Elliott Viney, 101 B–C

Mrs James Wardrop, 20 C, 35 B
Warren Editions, 54 C, 55 C, 76 C, 84 C, 85 B, 91, 99 B, 135 B, 138, 139 A,143
Mr James Wells, 39 F
Mr and Mrs Peter Wick, 144 A
The Dean and Chapter of Winchester, 29 A
Mrs Margaret Wind and the Dept. of the History of Art, Oxford, 121 B
By kind permission of the Master and Wardens of the Worshipful Company of Grocers, 132 C
Mr and Mrs Charles Worthington, 99 A

Mr Thomas Yoseloff, 47

SELECT BIBLIOGRAPHY

Arts Council, *Reynolds Stone: An Exhibition Catalogue of Engravings and Designs*, London, 1959.

Beddingham, Philip, Will Carter, Reynolds Stone, *Concerning Booklabels*, Private Libraries Association, London, 1963.

Bewick, Thomas, *Wood Engravings of Thomas Bewick*, selected with a biographical introduction by Reynolds Stone, Rupert Hart-Davis, London, 1953.

Carter, John, 'The Woodcut Calligraphy of Reynolds Stone', *Signature*, no. 2, March 1936, pp. 21–8.

Goodison, J. W., *Reynolds Stone: His Early Development as an Engraver on Wood*, 200 copies printed and bound at the University Press, Cambridge, for presentation by the University Printer to friends in printing and publishing, Christmas 1947.

McLean, Ruari, 'Contemporary British Craftsmen: Reynolds Stone', *Connoisseur*, vol. 154, September 1963, pp. 22–9.

Muir, Percy, 'The Engraved Letter-forms of Reynolds Stone', *Alphabet and Image*, no. 7, May 1948, pp. 3–13.

Piper, Myfanwy, *Reynolds Stone*, Art & Technics, London, 1951.

Raverat, Gwen, *The Wood Engravings of Gwen Raverat*, selected with an introduction by Reynolds Stone, Faber & Faber, London, 1959.

Stone, Reynolds, *A Book of Lettering*, A. & C. Black, London, 1935; 3rd edn., 1939.

Reviews of John Lewis, *Printed Ephemera* (Cowell) and Harry Carter, *Orlando Jewitt* (Clarendon Press), *Journal of the Royal Society of Arts*, vol. 111, March 1963, pp. 329–30 and 778.

Review of *The Engraved Work of Eric Gill* (Victoria & Albert Museum), *Journal of the Royal Society of Arts*, vol. 112, July 1964, pp. 622–3.

Reviews of R. S. Hutchings (ed.), *Alphabet* (James Moran) and John R. Biggs, *The Craft of Script* (Blandford Press), *Journal of the Royal Society of Arts*, vol. 113, April 1965, p.376.

'The Albion Press', *Printing Historical Society Journal*, vol. 2, 1966, pp. 58–73; vol. 3, 1967, pp. 97–9.

Review of James Sutton and Alan Bartram, *An Atlas of Typeforms* (Lund Humphries), *Journal of the Royal Society of Arts*, vol. 117, July 1969, p. 585.

'The Lapidary Life', review of John Sparrow, *Visible Words* (Cambridge University Press), *Listener*, vol. 83, 12 February 1970, pp. 220–1.

Review of A. S. Osley, *Mercator: A Monograph on the Lettering of Maps in the Sixteenth-Century Netherlands* (Faber & Faber), *Journal of the Royal Society of Arts*, vol. 118, September 1970, pp. 654–5.

'An Albion Press used by Hague and Gill', *Printing Historical Society Journal*, vol. 7, 1971, p. 64.

'Nature in the grain', review of *A Portfolio of Thomas Bewick Wood Engravings* (Newberry Library, Chicago, for Cherryburn Press), *Times Literary Supplement*, 30 July 1971, p. 882.

Review of Giovan Francesco Cresci, *A Renaissance Alphabet: Il Perfetto Scrittore, Parte Seconda* (University of Wisconsin Press), *Journal of the Royal Society of Arts*, vol. 120, January 1972, pp. 123–4.

'James Wardrop', *Bodleian Library Record*, vol. 8, June 1972, pp. 297–306.

'Stanley Morison', reviews of Nicolas Barker, *Stanley Morison* (Macmillan), James Moran, *Stanley Morison: His Typographical Achievement* (Lund Humphries) and Stanley Morison, *Politics and Script* (Oxford University Press), *Listener*, vol. 88, 17 August 1972, pp. 214–15.

Reviews of Roderick Cave, *The Private Press* (Faber & Faber) and William Blades, *The Biography and Typography of William Caxton* (Muller), *Journal of the Royal Society of Arts*, vol. 121, March 1973, p. 261.

'The master of the object', reviews of Margot Eates, *Paul Nash: The Master of the Image* (John Murray), Alexander Postan, *The Complete Graphic Work of Paul Nash* (Secker & Warburg) and Andrew Causey, *Paul Nash's Photographs* (Tate Gallery), *Times Literary Supplement*, 27 July 1973, p. 879.

Review of Allen Hutt, *Fournier: The Compleat Typographer* (Muller), *Journal of the Royal Society of Arts*, vol. 121, October 1973, p. 757.

'Across the grain', review of Edward Hodnett, *English Woodcuts, 1480–1535* (Oxford University Press), *Times Literary Supplement*, 1 February 1974, p. 110.

Review of A. S. Osley, *Luminario: An Introduction to the Italian Writing Books of the Sixteenth and Seventeenth Centuries* (Miland Publishers, Nieuwkoop, Netherlands), *Journal of the Royal Society of Arts*, vol. 122, March 1974, pp. 234–5.

Review of Ruari McLean, *Jan Tschichold: Typographer* (Lund Humphries), *Journal of the Royal Society of Arts*, vol. 124, July 1976, pp. 470–1.

'Caxton of Bruges', review of George D. Painter, *William Caxton* (Chatto & Windus), *Listener*, vol. 96, 28 October 1976, pp. 547–8.

Taylor, Jane, 'Reynolds Stone: Engraver', *Vogue*, vol. 134, July 1977, pp. 118–21. [Jane Taylor undertook the primary research for the Notes on pages xxiii–xxxvi.]

PLATES

B

A

C

D

MCMX-MCMXXXV

E

A

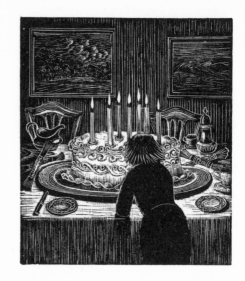

B

C

D

E

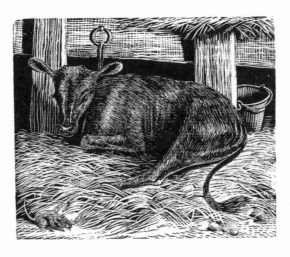

F

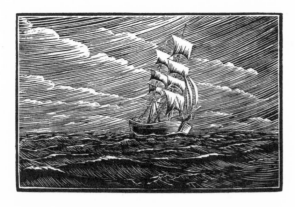

A

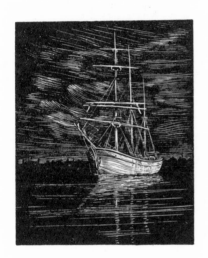

B

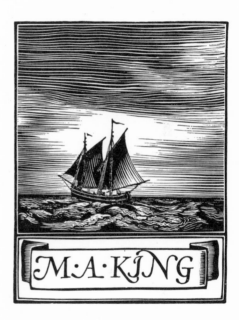

C

D

A

B

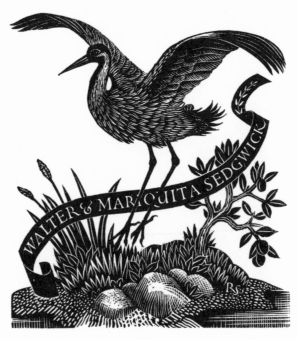

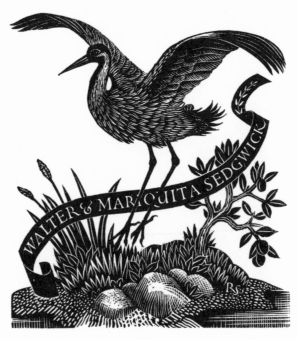

D

[4]

The Shakespeare Anthology

Poems
Poetical Passages
Lyrics

London: The Nonesuch Press
New York: Random House Inc.

Troylus and Cressida

HAMLET
Prince of Denmarke

A Midsommer
Night's Dreame

As You Like it

Cymbeline

JULIUS CAESAR

SONNETS

Anthonie and Cleopatra

Henry the Eighth

The COMEDIE of ERRORS

The Merry Wives of Windsor

Venus & Adonis

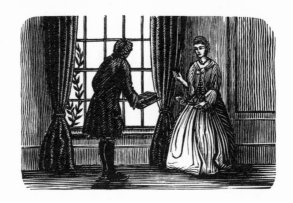

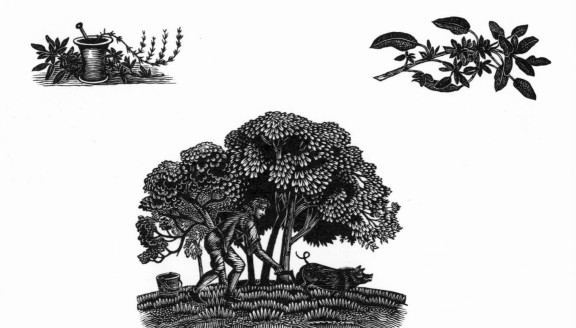

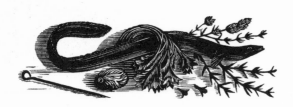

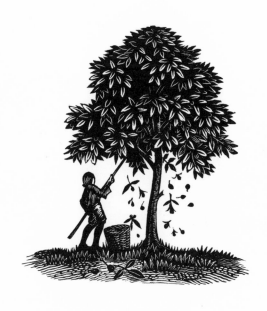

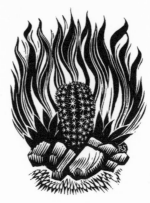

A

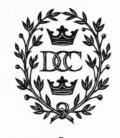

B

C

D

F

E

G

A

B

C

D

E

F

G

A

B

C

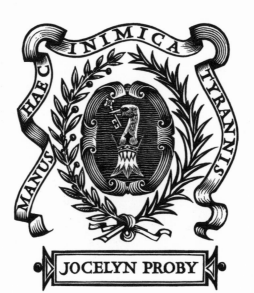

D

E

F

G

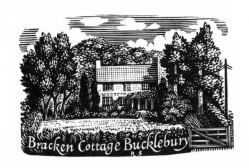

A

B

C

D

E

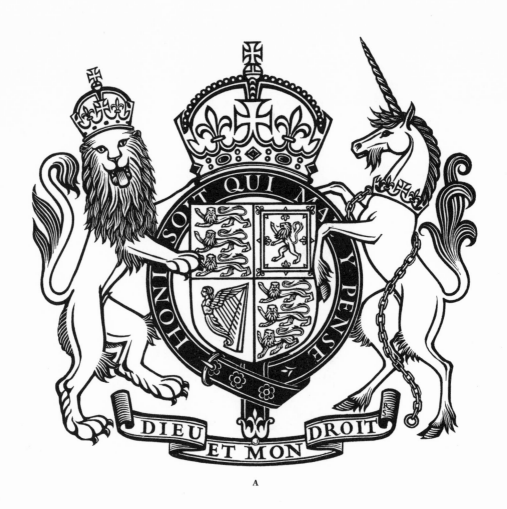

A

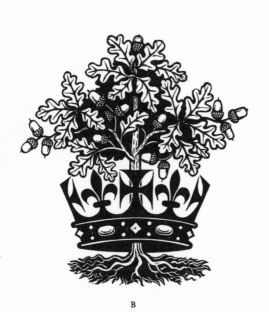

B

C

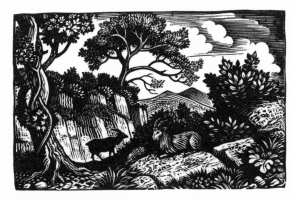

A

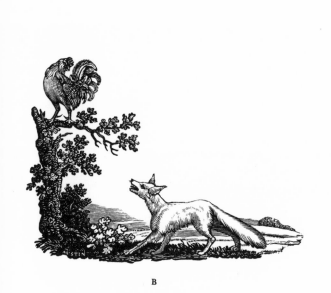

B

C

D

E

A

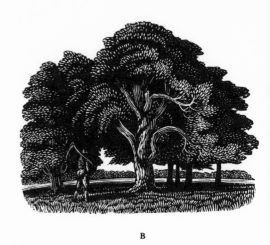

B

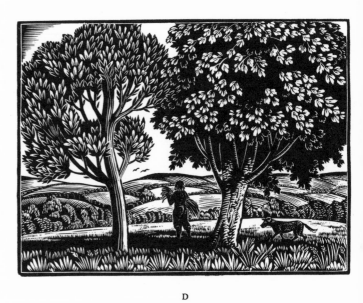

C

D

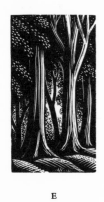

E

F

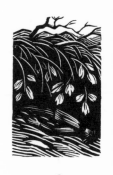

G

THE
PRAISE AND HAPPINESSE
OF THE
COUNTRIE-LIFE

Written originally in Spanish by
DON ANTONIO DE GUEVARA

Put into English by
H. VAUGHAN, SILURIST

Virgil. Georg.
O fortunatos nimium, bona si sua norint,
Agricolas!———

Reprinted from the edition of 1651, with an
introduction by *Henry Thomas*, and
wood engravings by *Reynolds Stone*

AT THE GREGYNOG PRESS
NEWTOWN
1938

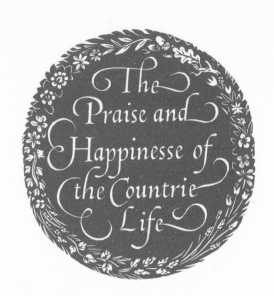

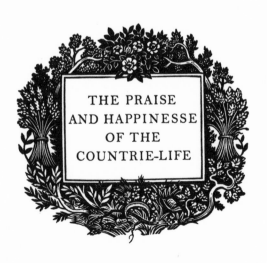

THE PRAISE
AND HAPPINESSE
OF THE
COUNTRIE-LIFE

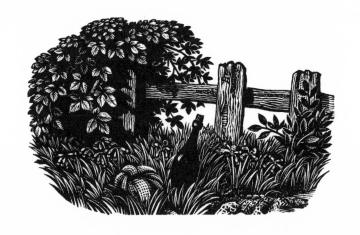

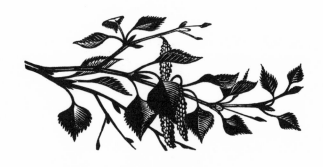

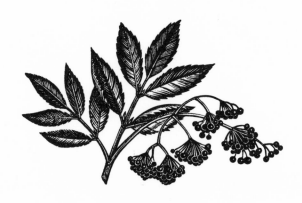

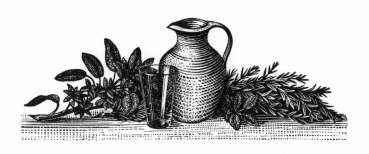

A

B

C

D

E

F

G

H

I

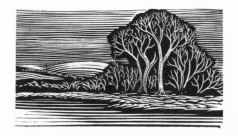

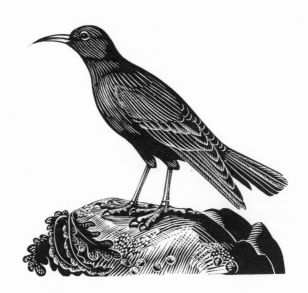

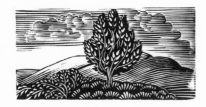

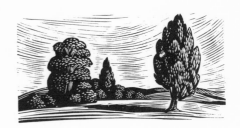

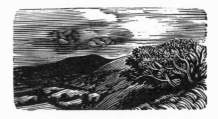

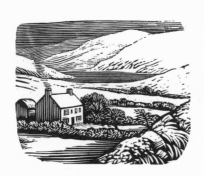

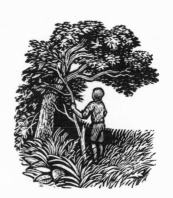

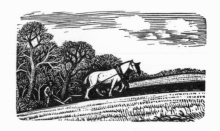

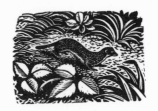

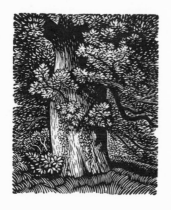

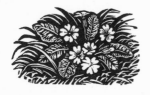

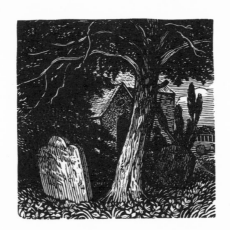

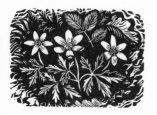

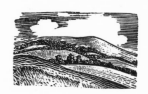

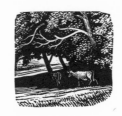

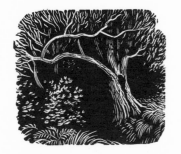

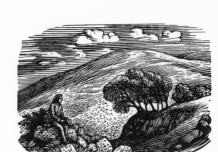

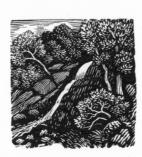

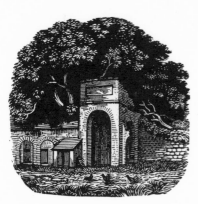

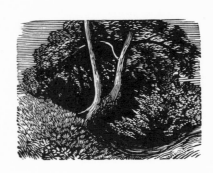

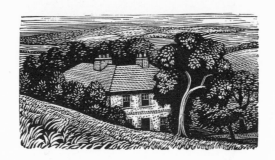

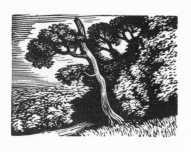

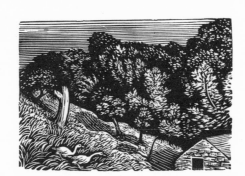

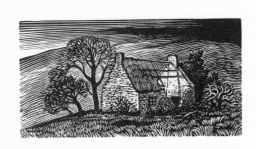

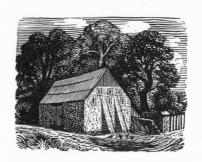

BREVIARIUM ROMANUM

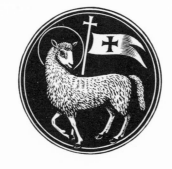

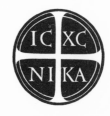

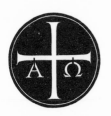

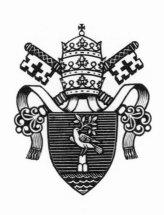

ORDINARIUM DIVINI OFFICII
JUXTA
RITUM ROMANUM
PERSOLVENDI

CENTVM HVIVSCE FASCICVLI EXEMPLARIA
TYPIS ACADEMIAE CANTABRIGIENSIS
IMPRIMENDA CVRAVIT
STANLEY MORISON
A D MDCCCCXXXXIII
NE INTER ARMA OMNINO SILERENT
CLARIVS POST TVMVLTVS FORTASSE LOCVTVRAE
ARTES HVMANIORES

A

LAPIDARIA

B

IN MEMORY OF ANTHONY
EVELYN LOVEDAY SCHUSTER
AT ETON 1934-1939. LIEUTENANT
WELSH GUARDS. KILLED IN
ACTION ON MONTE CERASOLA
BY THE GARIGLIANO ITALY
13 FEBRUARY 1944 AGED 22 YEARS

C

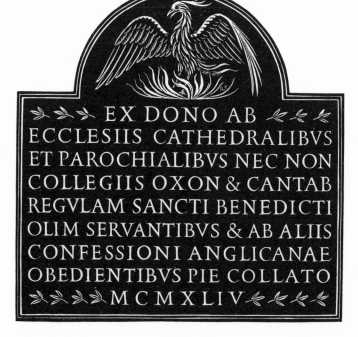

EX DONO AB
ECCLESIIS CATHEDRALIBVS
ET PAROCHIALIBVS NEC NON
COLLEGIIS OXON & CANTAB
REGVLAM SANCTI BENEDICTI
OLIM SERVANTIBVS & AB ALIIS
CONFESSIONI ANGLICANAE
OBEDIENTIBVS PIE COLLATO
MCMXLIV

A

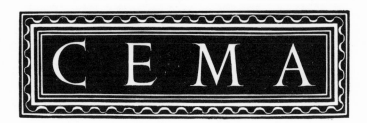

CEMA

B

PURCHASED OUT OF THE
HENRY MARTINEAU FLETCHER
MEMORIAL TRUST FUND
If a man love the labour of any trade,
apart from any question of success or
fame, the gods have called him RLS

C

A

B

C

D

E

F

A

B

C

D

John Waynflete Carter

E

A

B

C

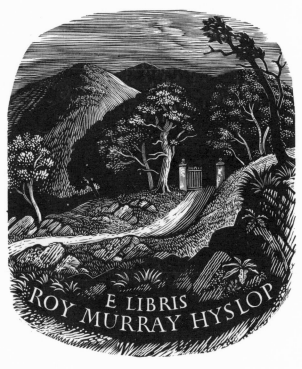

D

A

B

C

D

E

F

[35]

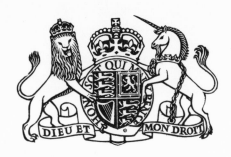

A

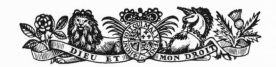

B

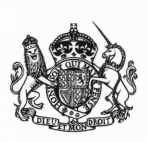

C

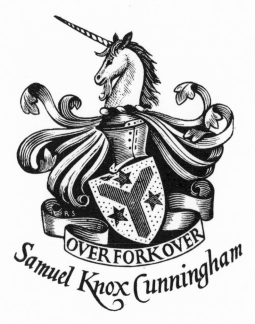

D

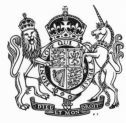

E

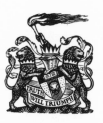

F

G

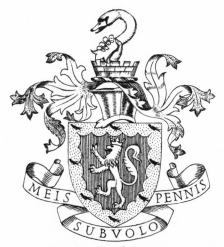

David Garnett

HILTON HALL HUNTINGDON

A

B

Grosvenor, Chater & Co. Ltd.

C

D

E

F

A

B

C

D

E

F

G

H

10 Hertford Street
London W1
GROSVENOR
3477

I

J

A

B

C

D

E

F

G

A

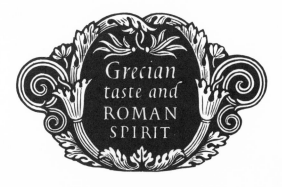

B

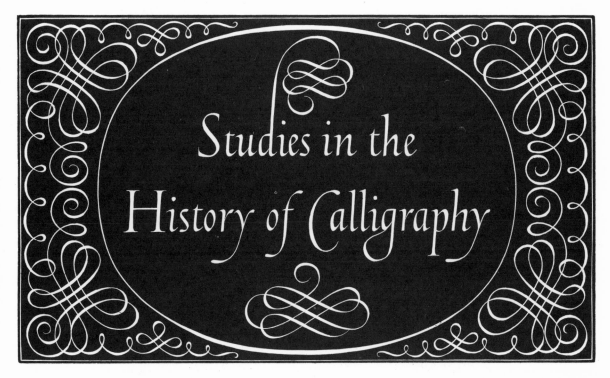

C

D

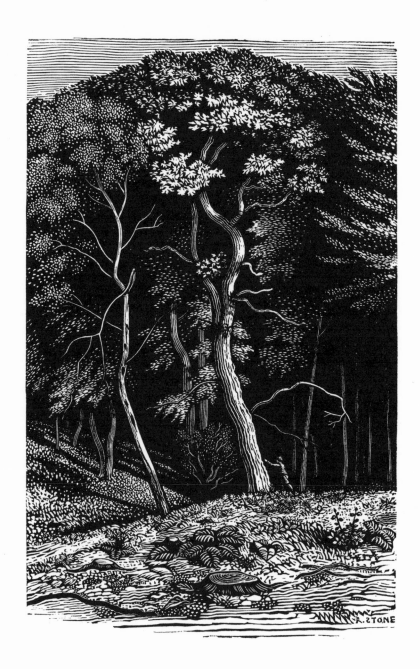

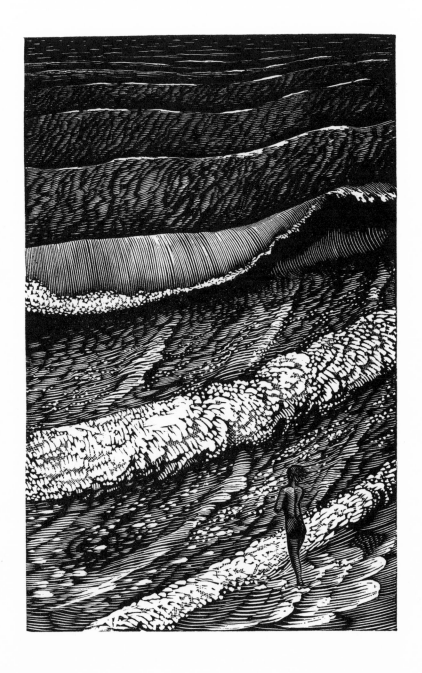

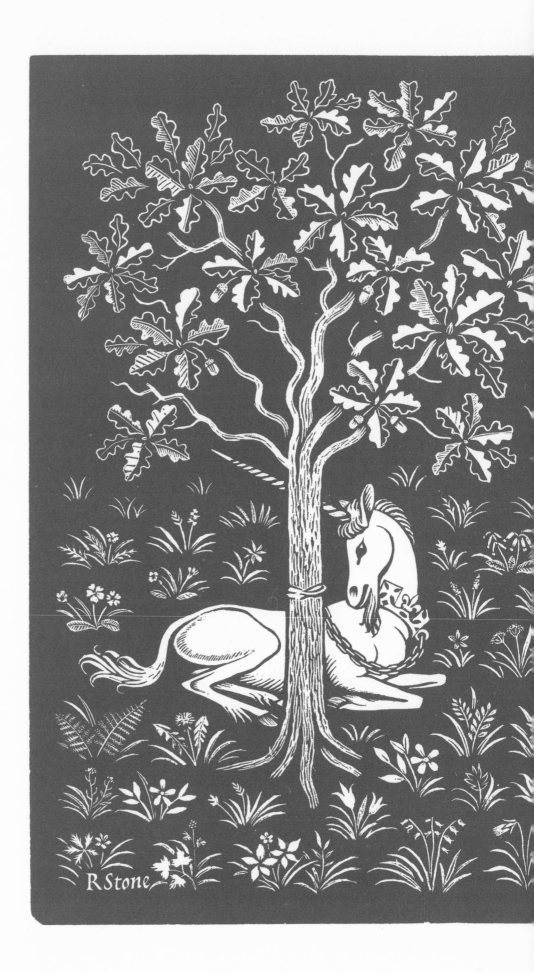

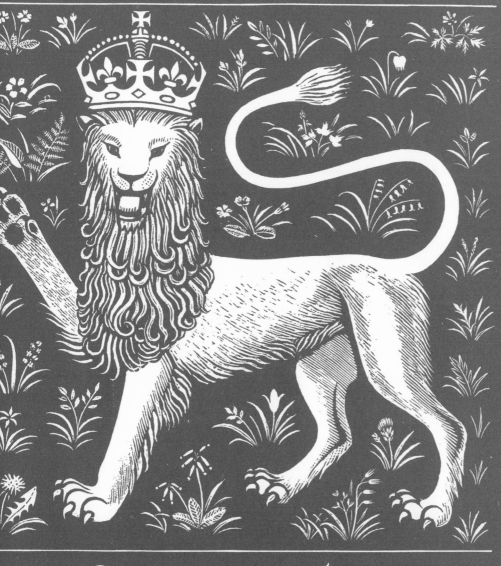

WINDSOR

Official Guide

A

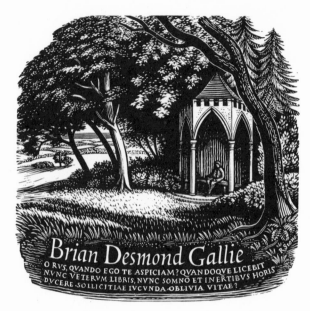

Brian Desmond Gallie

O RVS, QVANDO EGO TE ASPICIAM? QVANDOQVE LICEBIT
NVNC VETERVM LIBRIS, NVNC SOMNO ET INERTIBVS HORIS
DVCERE SOLLICITIAE IVCVNDA OBLIVIA VITAE?

B

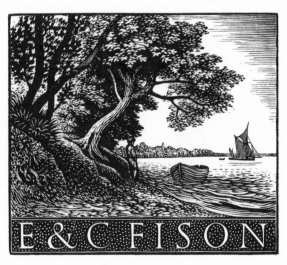

E & C FISON

C

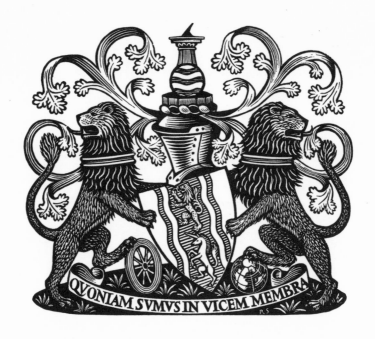

A

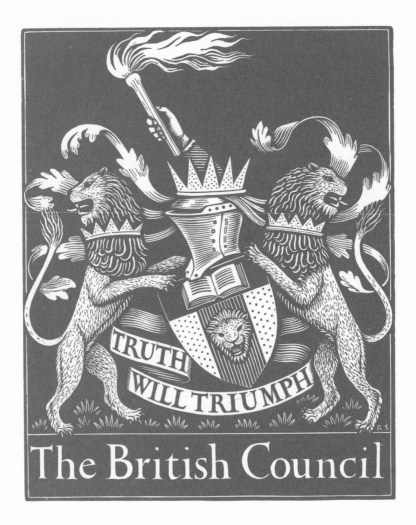

B

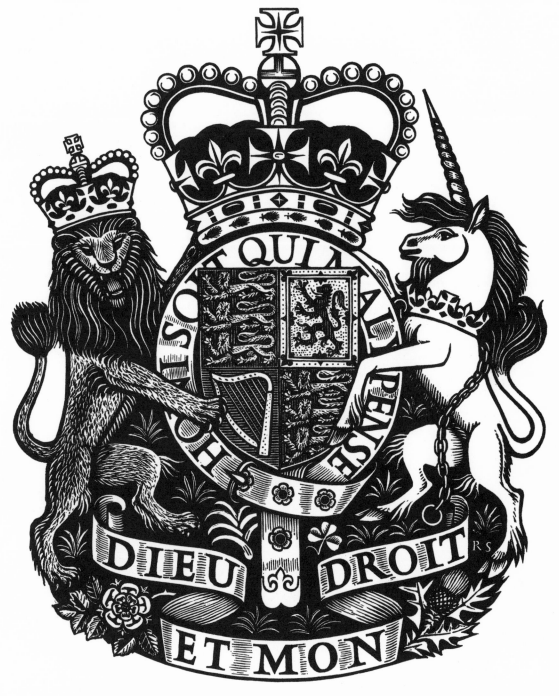

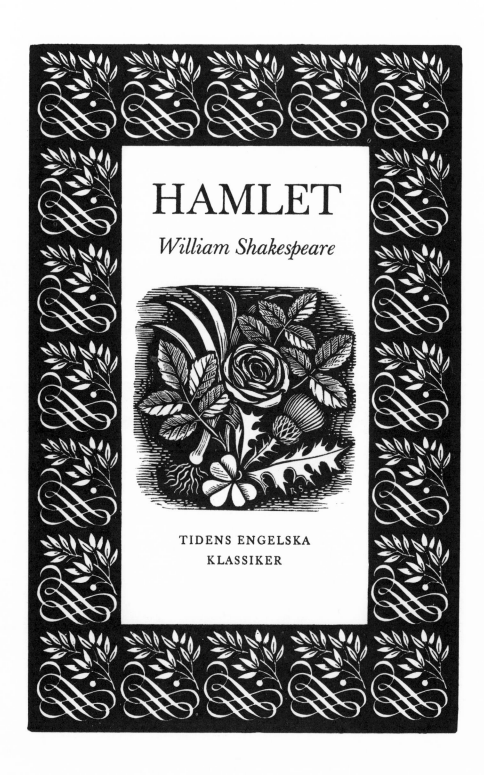

HAMLET

William Shakespeare

TIDENS ENGELSKA
KLASSIKER

ABCD
EFGH
IJKLM
NOPQ
RSTUV
WXYZ

Reynolds Stone sc. 1950

A

B

C

D

E

F

G

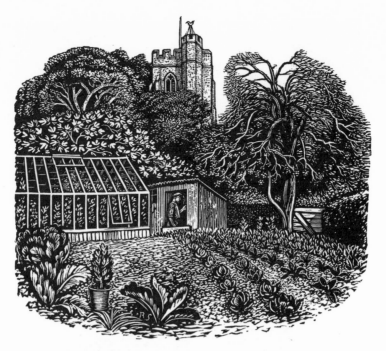

A

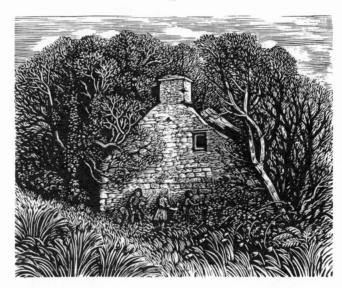

B

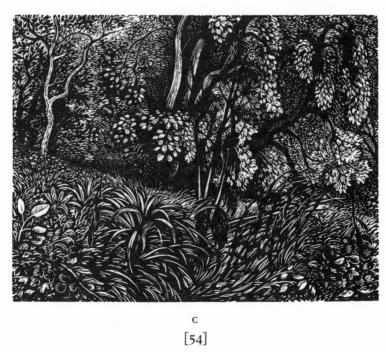

C

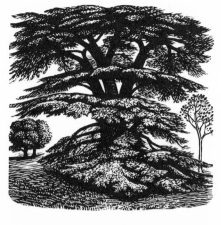

A

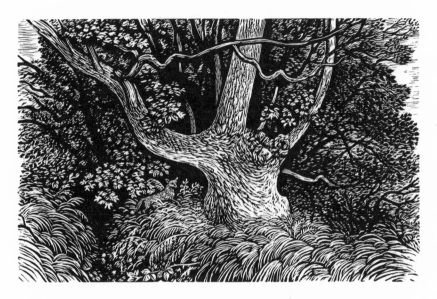

B

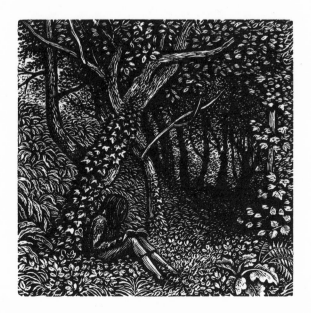

C

By
her gracious permission
this edition is
DEDICATED
to Her Majesty
QUEEN
ELIZABETH II
by her dutiful and
devoted servants of

THE NONESUCH PRESS
in the year of her Coronation
MCMLIII

A

B

MINERVA

48 POINT
capitals only

ABCDEFGHIJKLMNO

48 point bold in process

42 POINT
capitals only

ABCDEFGHIKLMNOPQ

42 point bold in process

36 POINT

ABCDEFGHabcdefghijklmn

36 point italic and bold in process

30 POINT

ABCDEFGHIJ abcdefghijklmnopq

30 point italic and bold in process

24 POINT
with italic or bold

ABCDEFGHIJ 12345 abcdefghijklm 12345

24 POINT
with roman

ABCDEFGHIJ 12345 abcdefghijklm 12345

24 POINT
with roman

ABCDEFGHIJ 12345 abcdefghijklm 12345

18 POINT
with italic or bold

ABCDEFGHIJKLM 67890 abcdefghijklmnopqr 67890

18 POINT
with roman

ABCDEFGHIJKLM 67890 abcdefghijklmnopqr 67890

18 POINT
with roman

ABCDEFGHIJKLM 67890 abcdefghijklmnopqr 67890

MINERVA

DESIGNED FOR LINOTYPE BY REYNOLDS STONE

The *admirable Minerva* seems to have made the tour of the nations of mankind, and casually come in contact with them all, from one end of the world to the other, that she might communicate herself to each . . . *she has at last happily reached Britain*

RICHARD DE BURY: *PHILOBIBLON*

ABCDEFGHIJKLMNOPQRSTUVWXYZ

Super
canem ignarum
vulpes
celer rufaque
salit
ANON

Una dies media est, et fiunt sacra Minervae,
nomina quae iunctis quinque diebus habent.
Sanguine prima vacat, nec fas concurrere ferro:
causa, quod est illa nata Minerva die.
Altera tresque super strata celebrantur harena:
ensibus exertis bellica laeta dea est. OVID: *FASTI*

VIRTUE IS LIKE A RICH STONE, BEST PLAIN SET

FRANCIS BACON

A

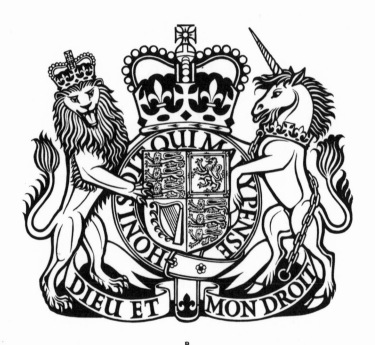

B

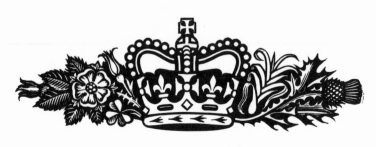

C

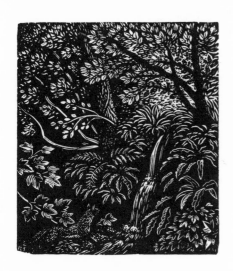

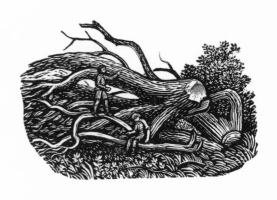

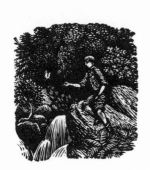

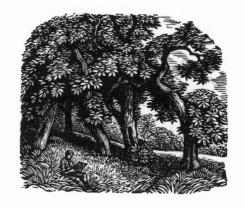

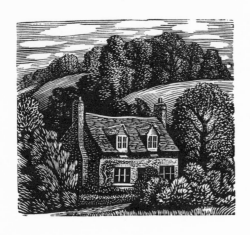

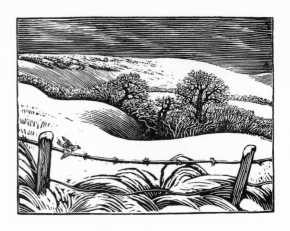

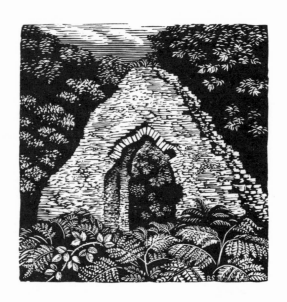

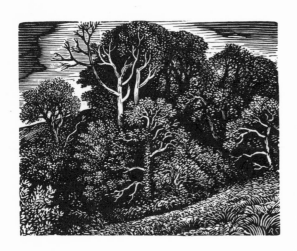

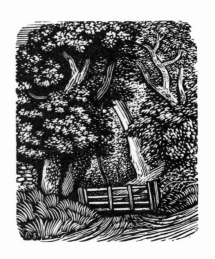

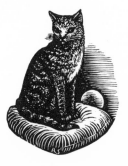

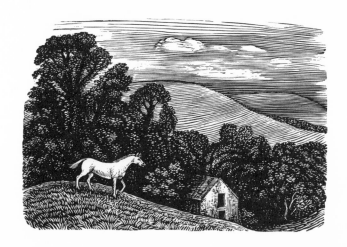

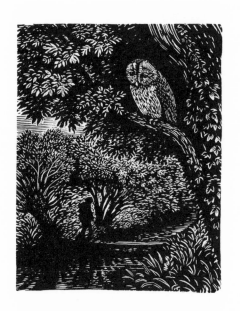

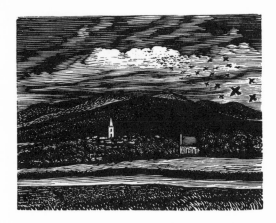

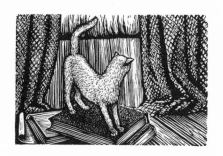

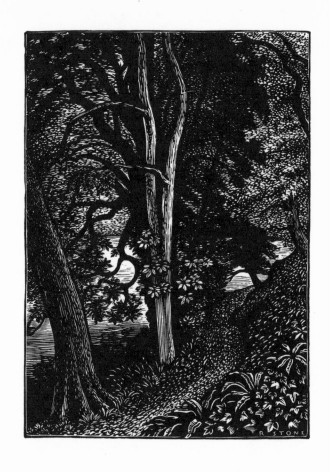

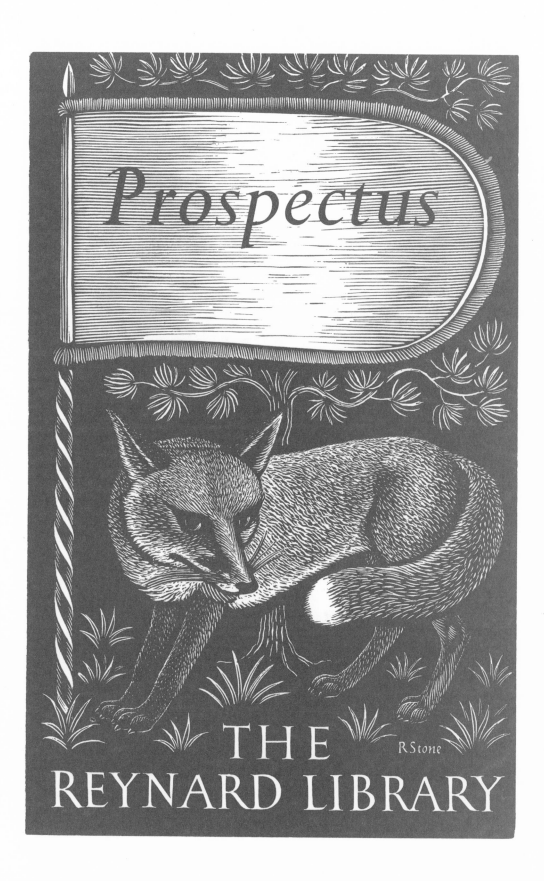

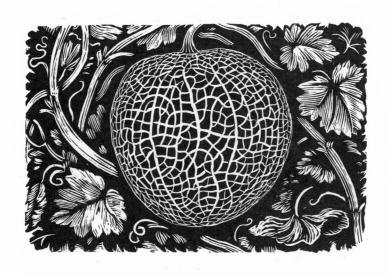

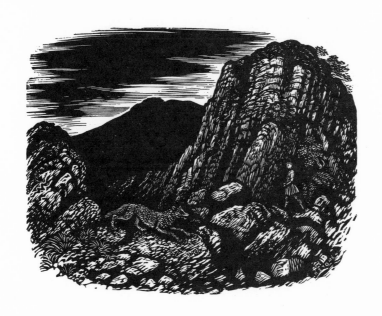

A

B

C

D

ABCDEFG
HIJKLMN
OPQRSTU
VWXYZ&
abcdefghijkl
mnopqrstuv
wxyz&abcdef
ghijklmnopqrs
tuvwxyz Reynolds Stone 1953

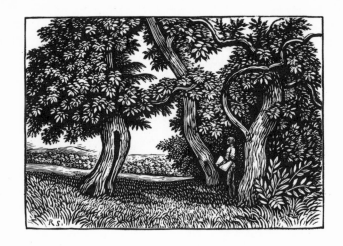

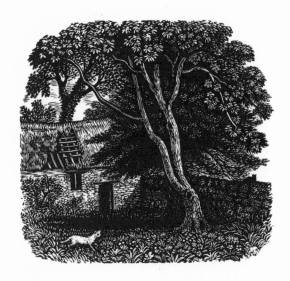

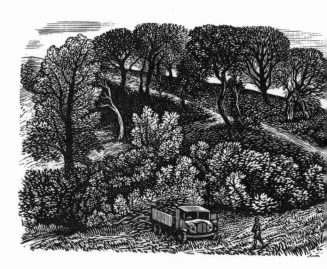

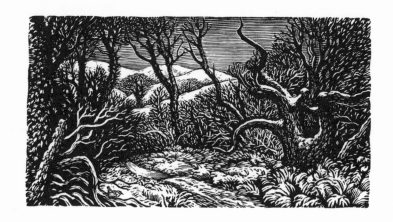

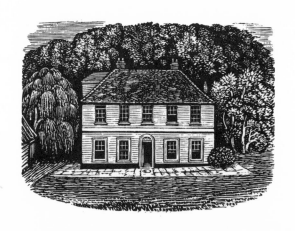

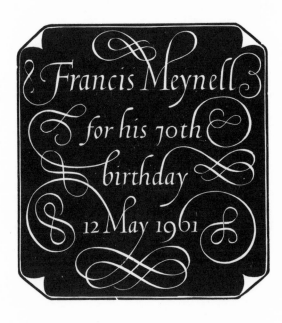

Francis Meynell
for his 70th
birthday
12 May 1961

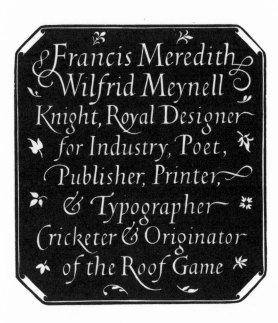

Francis Meredith
Wilfrid Meynell
Knight, Royal Designer
for Industry, Poet,
Publisher, Printer,
& Typographer
Cricketer & Originator
of the Roof Game

THE
GOS
PEL
AS RECORDED BY
MARK

A

B

C

D

E

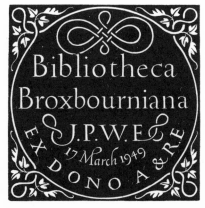

A

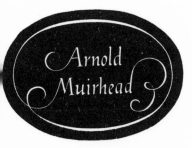

B

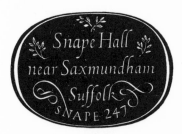

C

D

E

A

B

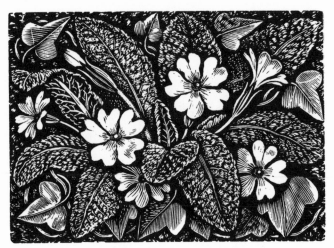

C

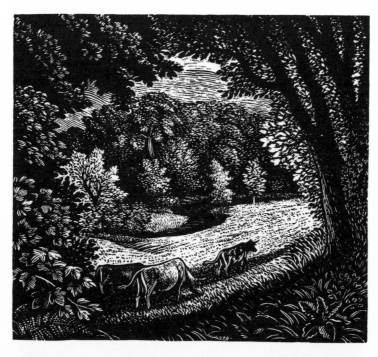

FROM DARKNESS TO LIGHT

a Confession of Faith in the form of an Anthology

by

Victor Gollancz

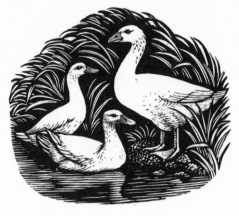

A

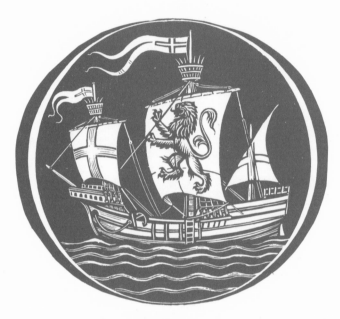

B

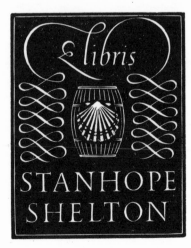

C

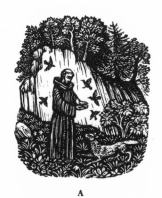

A

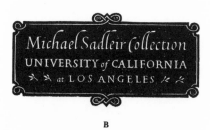

B

C

D

E

AD MAIOREM DEI GLORIAM NECNON IN PIAM MEMORIAM

CAROLI GUGLIELMI BRODRIBB

LONDINII SUI AMATORIS ET SANCTAE ECCLESIAE ALUMNI FIDELISSIMI

QUI LITTERIS BONIS IPSE PENITUS IMBUTUS

RES HOMINESQUE COMMENTARIIS DIURNIS ACUTE AESTIMABAT

HI DEDICATI SUNT SCRIPTURARUM SACRARUM LIBRI

AEDIS OMNIUM SANCTORUM IUXTA TURRIM POST BELLI INIURIAS

RENASCENTIS PRIMITIAE

ABCDEFGHIJKLM
NOPQRSTUVWXYZ
abcdefghijklmnopqrstu
vwxyz;.)&abcdefghijklmnop,
qqurstvwxyz&g.123456789)!?:

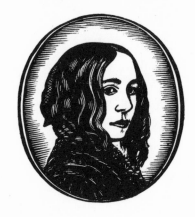

A

B

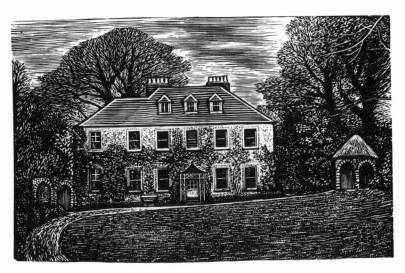

C

A

B

C

A

B

C

D

E

F

G

H

A

B

A STUDY OF FINE TYPOGRAPHY
THROUGH FIVE CENTURIES

EXHIBITED IN UPWARDS OF
THREE HUNDRED AND FIFTY
TITLE AND TEXT PAGES DRAWN
FROM PRESSES WORKING IN
THE EUROPEAN TRADITION

WITH AN INTRODUCTORY ESSAY
BY STANLEY MORISON
AND SUPPLEMENTARY MATERIAL
BY KENNETH DAY

LONDON ERNEST BENN LTD 1963

THE
TYPOGRAPHIC
BOOK
1450-1935

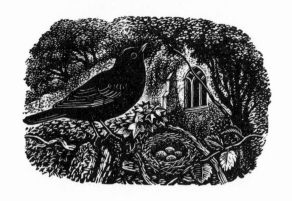

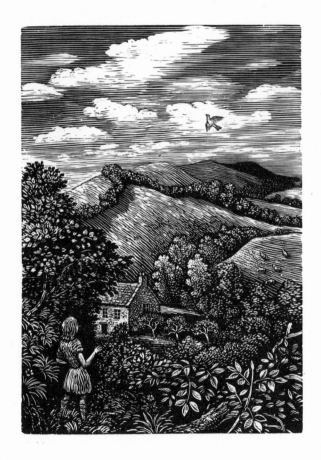

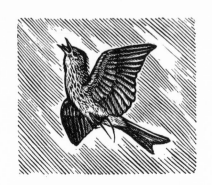

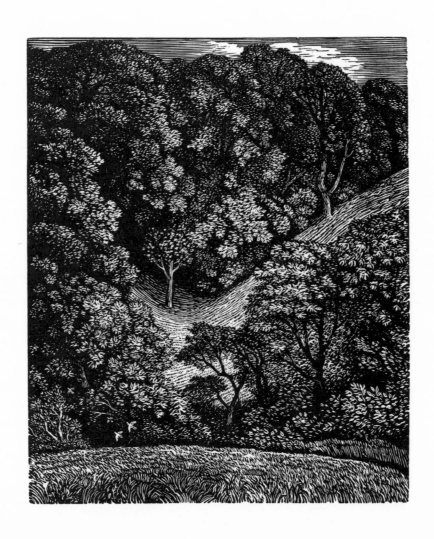

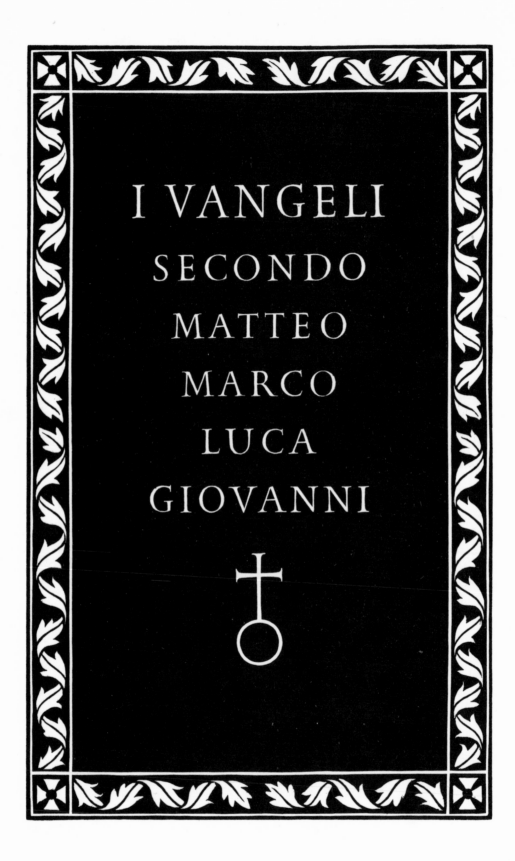

I VANGELI

SECONDO

MATTEO

MARCO

LUCA

GIOVANNI

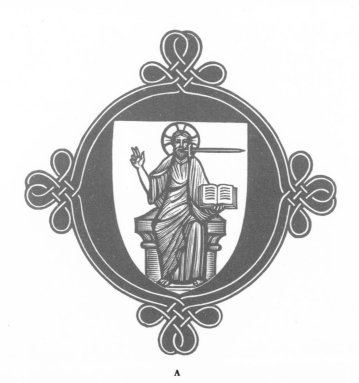

A

B C D

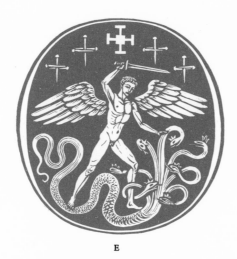

E

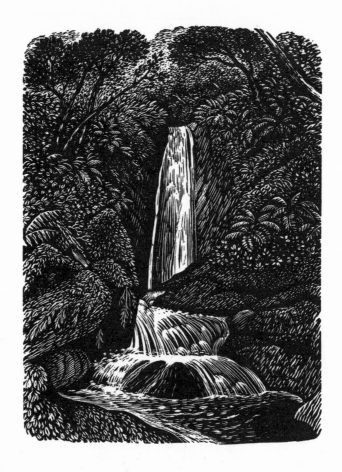

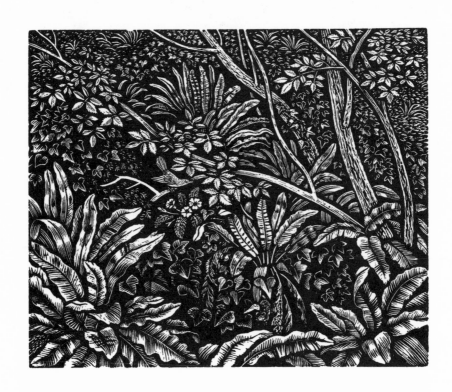

A

B

C

A

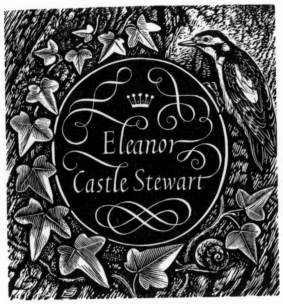

B

C

A

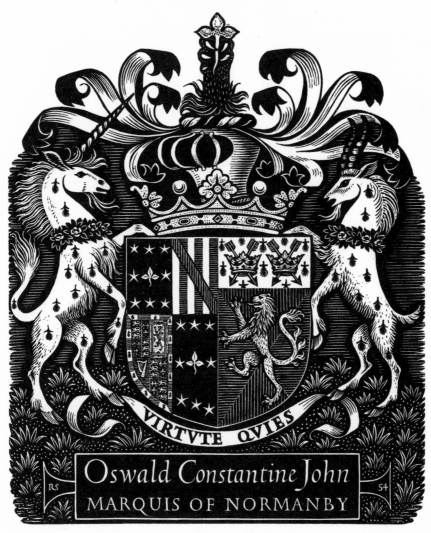

VIRTVTE QVIES

Oswald Constantine John
MARQUIS OF NORMANBY

B

A

B

C

A

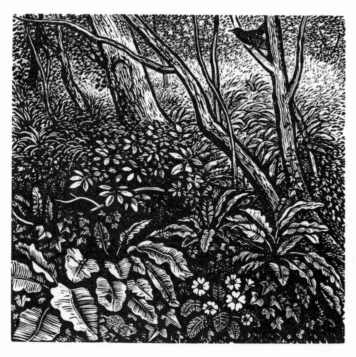

B

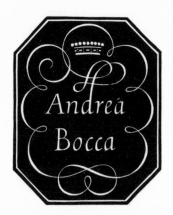

A

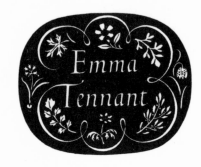

B

D

C

E

F

A

B

C

D

E

F

G

A

B

C

A

B

A

B

C

A

B

C

D

E

F

G

OMOO

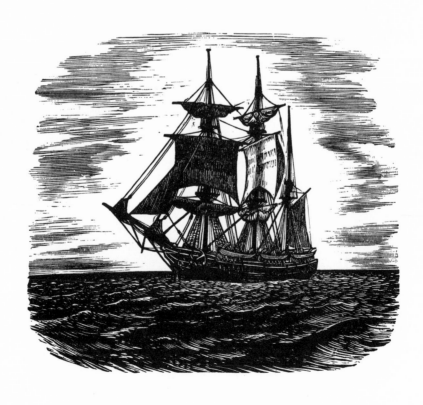

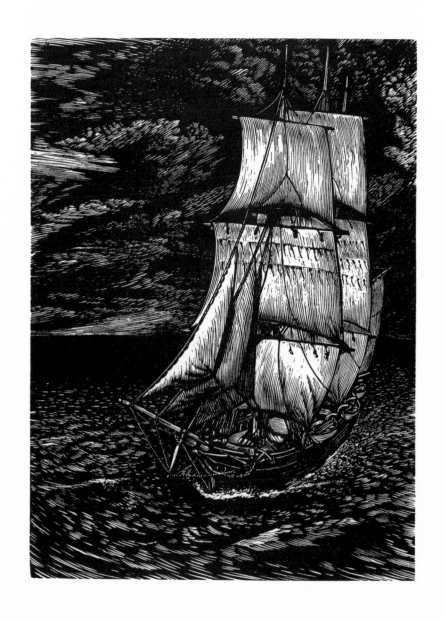

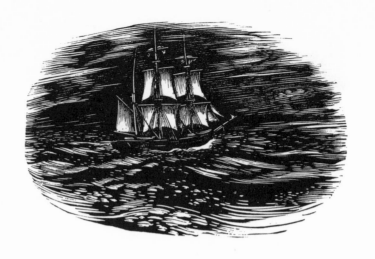

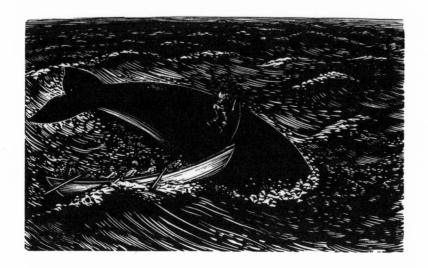

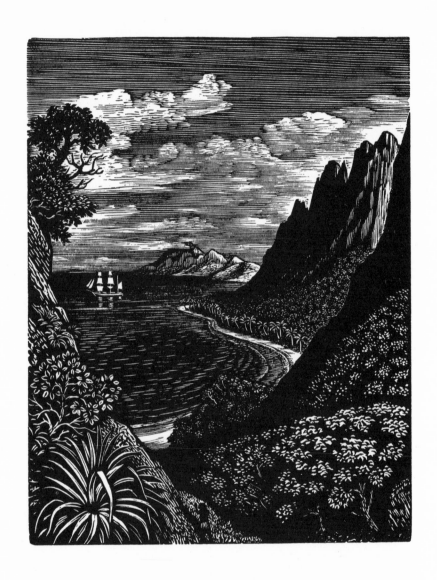

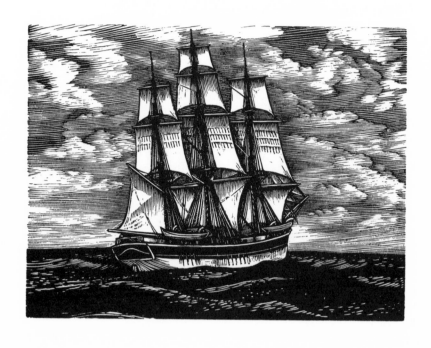

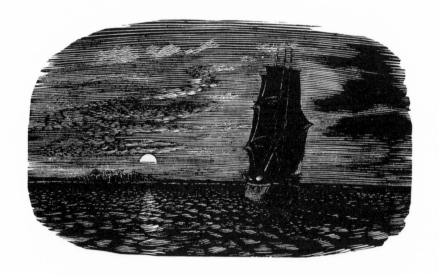

A

B

Duncan Guthrie

C

Oliver Millar

D

E

F

A

B

C

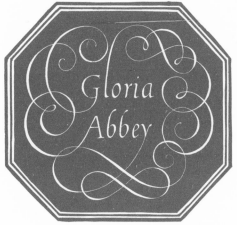

D

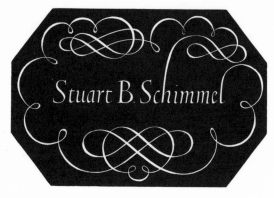

E

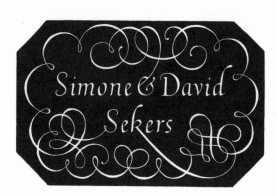

F

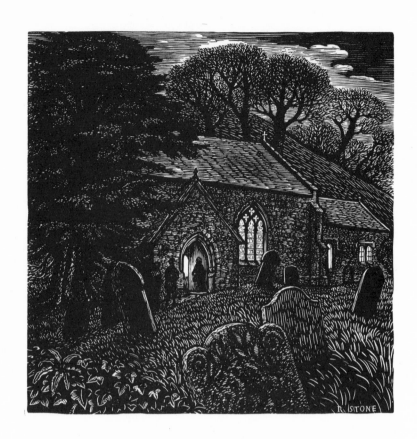

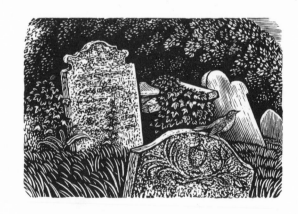

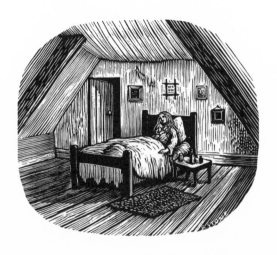

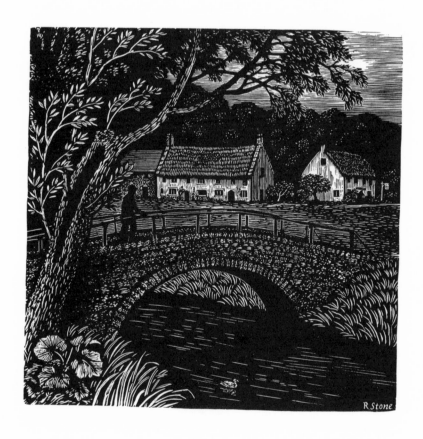

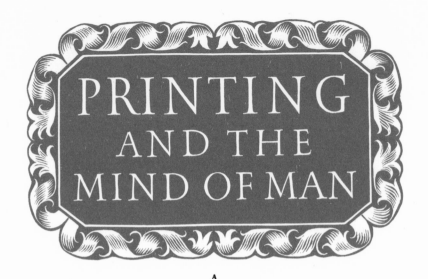

A

B

C

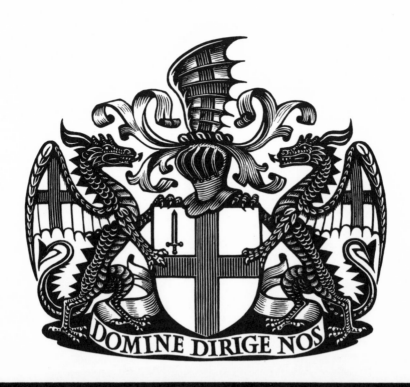

DOMINE DIRIGE NOS

GUILDHALL BANQUET
MONDAY 13 NOVEMBER 1967
The Right Honourable The Lord Mayor
Sir Gilbert Inglefield TD

Sheriffs

Alderman Peter Malden Studd Lindsay Roberts Ring Esquire

A DESCRIPTIVE CATALOGUE ILLUSTRATING THE IMPACT OF PRINT ON THE EVOLUTION OF WESTERN CIVILIZATION DURING FIVE CENTURIES

COMPILED AND EDITED BY
JOHN CARTER & PERCY H. MUIR
ASSISTED BY NICOLAS BARKER
H. A. FEISENBERGER, HOWARD NIXON
AND S. H. STEINBERG

WITH AN
INTRODUCTORY ESSAY BY
DENYS HAY

PRINTING AND THE MIND OF MAN

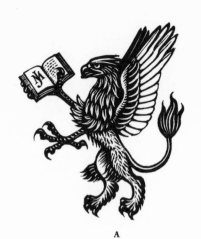

A

B

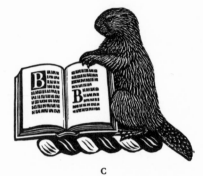

C

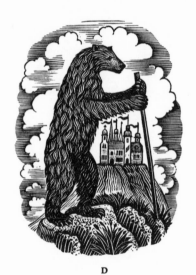

D

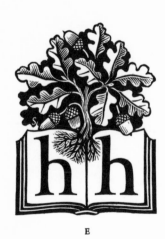

E

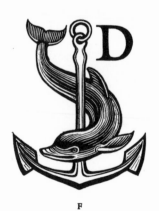

F

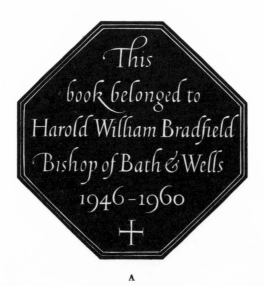

A

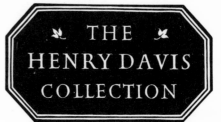

B

C

D

A

B

B

A

C

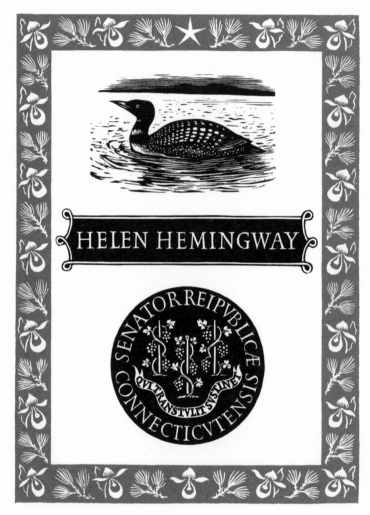

HELEN HEMINGWAY

SENATOR·REIPVBLICÆ
CONNECTICVTENSIS
QVI·TRANSTVLIT·SVSTINET

D – G

H

LVX ET VERITAS

I

CRES·CAT·SCI·ENTIA VITA·EXCO·LATVR

J

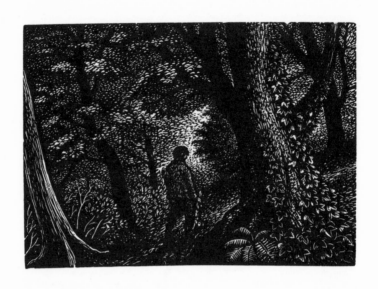

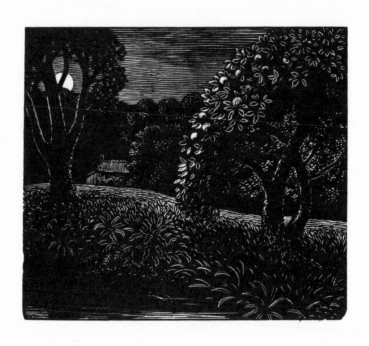

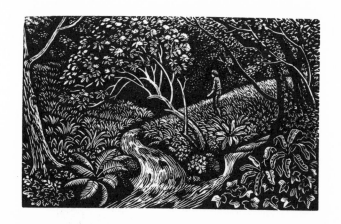

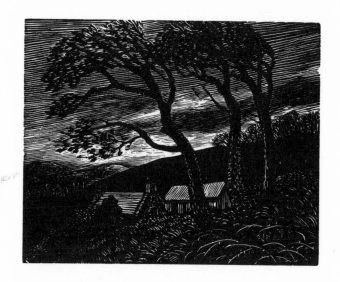

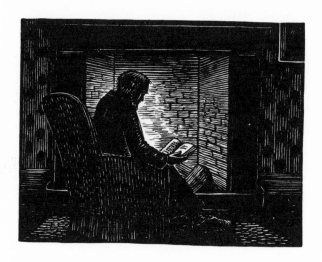

SAINT THOMAS AQUINAS

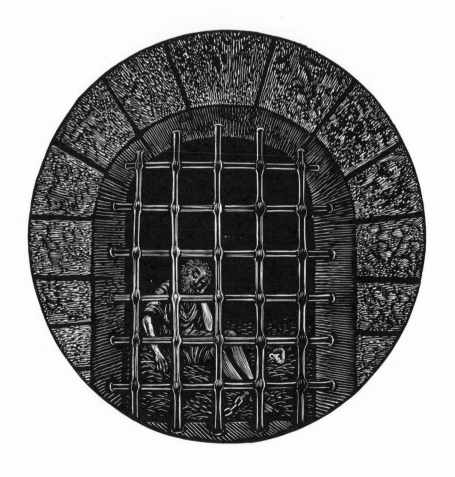

CREATION

HUMAN
SOCIETY

REFLECTIONS
ON THE DIVINE
NATURE

CORPUS
CHRISTI

A

FIDE

B

GOD GRANT GRACE

C

ST LOUIS
PRIORY SCHOOL
LIBRARY

A

B

C

D

A

B

C

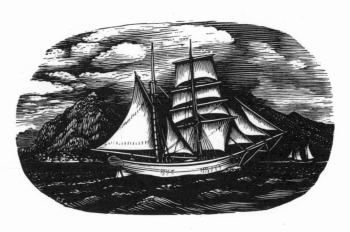

D

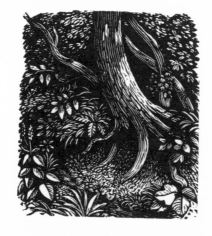

A

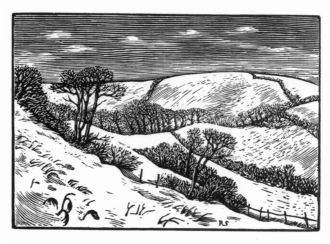

B

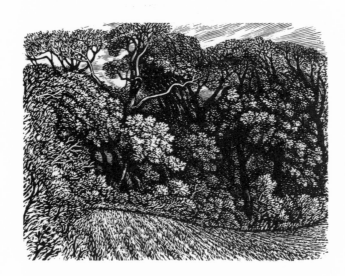

C

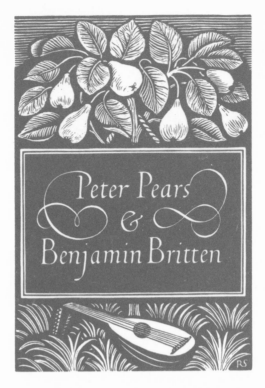

A

B

A

B

C

D

E

JOHN
MURRAY

F

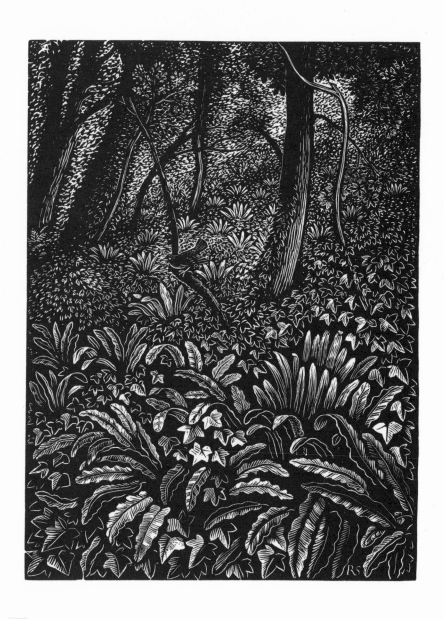

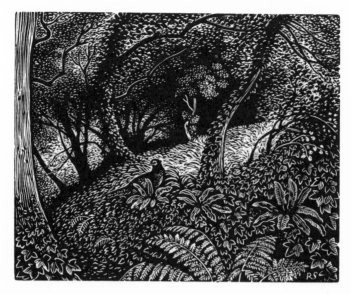

A

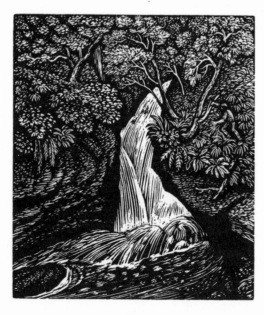

B

A

B

C

D

A

B

C

A

B

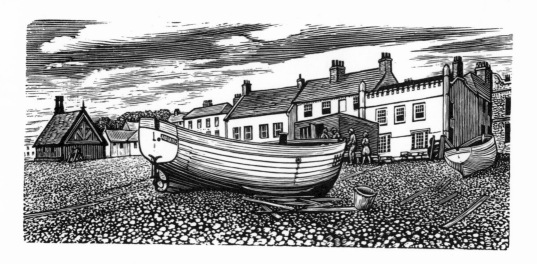

A

B

C

D

E

A

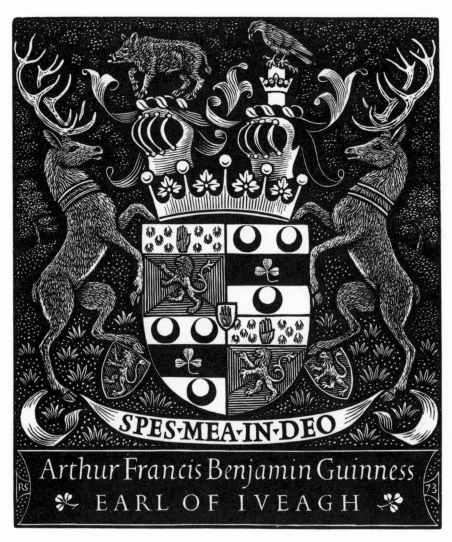

SPES·MEA·IN·DEO

Arthur Francis Benjamin Guinness

❀ EARL OF IVEAGH ❀

B

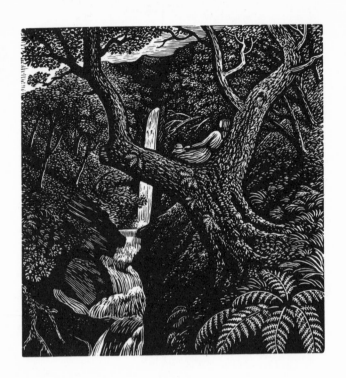

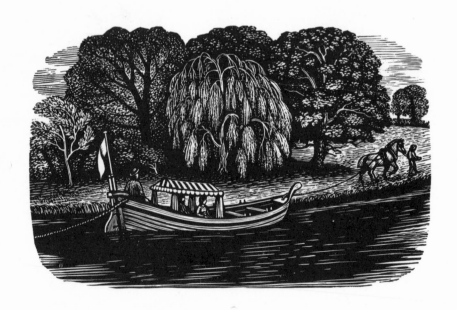

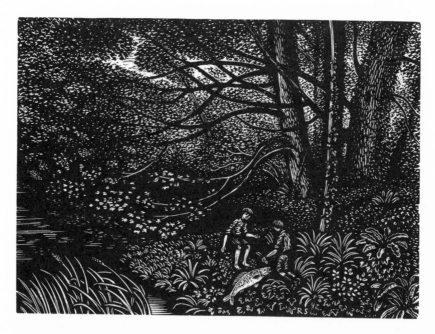

A

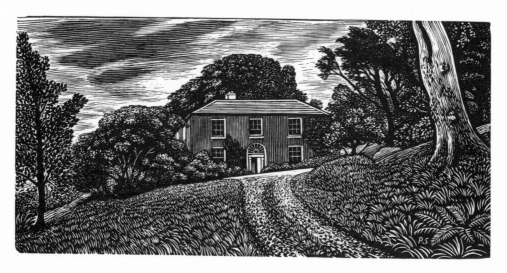

B

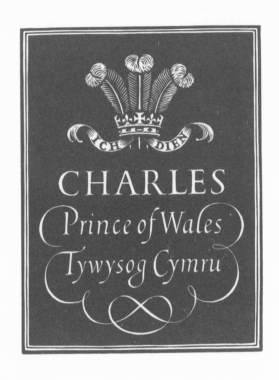

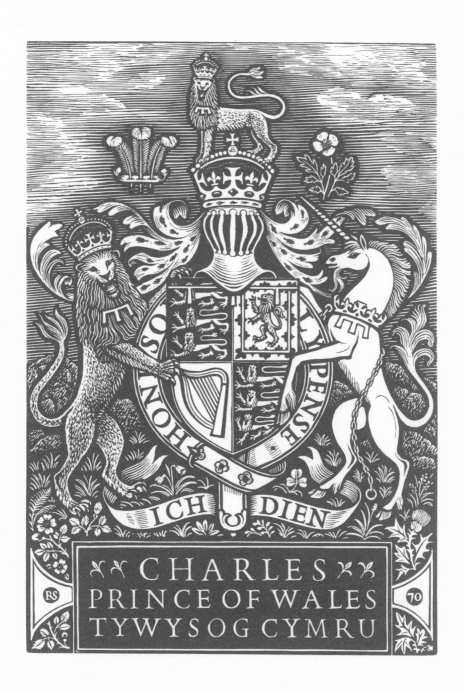

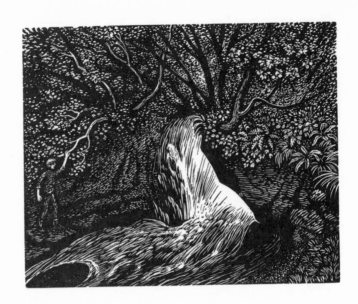

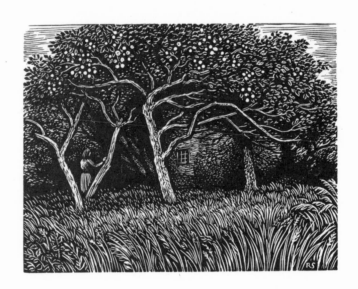

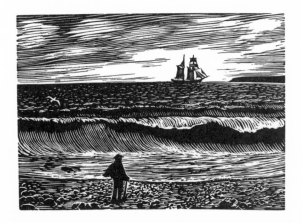

A

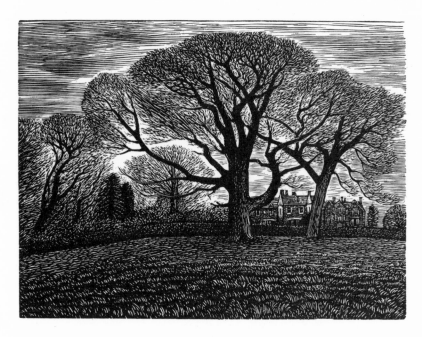

B

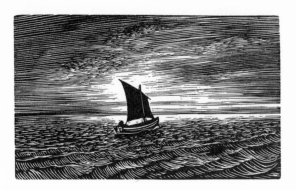

C

PRINTED AT THE CURWEN PRESS
ON BASINGWERK PARCHMENT
MADE BY GROSVENOR CHATER
AND BOUND IN FULL BUCKRAM
BY W & J MACKAY